ARTFUL
PAPER CLAY

TECHNIQUES FOR ADDING DIMENSION TO YOUR ART

ROGENE MAÑAS

NORTH LIGHT BOOKS
CINCINNATI, OHIO
clothpaperscissors.com

Contents

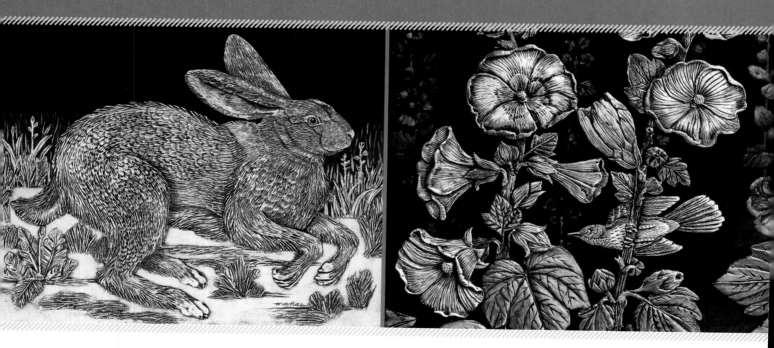

 Part 1
WORKING WITH CLAY 14

Learn all about working with the clay by following a progression of simple, hands-on practice projects. Apply clay to mini boards, then practice shaping, imprinting and sculpting it. Plus learn to make appliqués and custom molds for adding elements to mixed-media work.

 Part 2
CLAY WORK PROJECTS 44

Create five beautiful, full-sized clay work projects that incorporate all the skills you learned in Part 1. Each project gets progressively more complex and challenging as you move forward. Complete them in order to improve your sculpting and detailing skills as you work.

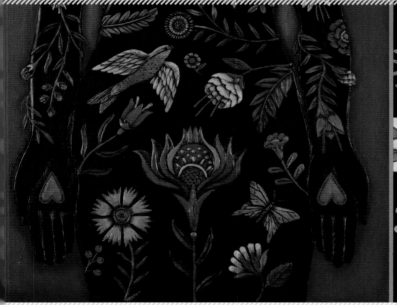
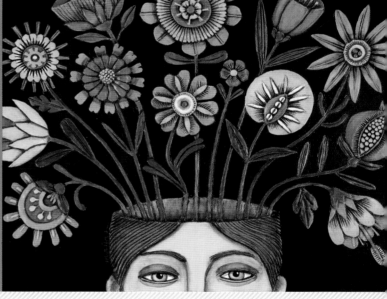

 Part 3
FINISHING TECHNIQUES 78

Now that you have created five beautiful dried clay works, it's time to finish and enhance your projects with color. Learn to seal your clay work with mediums, finish your projects with a variety of acrylic painting techniques and add collage materials for a full mixed-media look.

 Part 4
CREATIVE PROJECTS 124

Tap into your creative energy and get experimental! In this section you'll find a variety of project ideas involving mixed-media techniques plus other fun ways to use paper clay to create two- and three-dimensional art. Also learn a few inexpensive framing ideas that are both inside and outside of the box.

Introduction

As a mixed-media artist, I am always experimenting with materials, tools and techniques. I am forever in search of fun and forgiving ways to make art. More than ten years ago, I began adding air-hardening clay to my paintings after a fellow artist introduced me to the paper clay she used in doll making. For me, it was love at first sight and the ultimate mixed-media material because it held detail, adhered to my boards and canvases, and could be used in conjunction with lots of other materials. Working with the clay is such an enjoyable process that I soon became addicted to it.

I began teaching workshops by popular demand. Once people saw my work, they wanted to know how it was made. My students quickly discovered how easy paper clay was to use and master. And now, years later, I have compiled this comprehensive book to share all the ways I have discovered to use paper clay in bas-relief. It adds a sculptural element to two-dimensional work that makes it jump right off the board.

This book is for the experimenter. It's for beginning and accomplished artists alike who are looking for new ways of creative expression. If you've tried different methods of making art and nothing has really grabbed you, or if you are new to art and just don't know where to begin, this might be your medium.

Paper clay is perhaps the most versatile medium I have ever used. And because it is first sculpted and then painted, it fulfills my desire to work in a variety of mediums on a single project. The process is enjoyable from start to finish, and the results are very rewarding. It has given me a new way to express my thoughts and feelings that was missing from my previous work. It adds a dimensional quality, which I adore, giving weight and presence to my ideas.

This book is divided into four sections: Working with Clay, Clay Work Projects, Finishing Techniques and Creative Projects. In section 1, you will learn all about working with clay in bas-relief and create several mini practice projects. Section 2 is composed of five complete demonstrations of clay projects. In the final sections, you will take your projects to completion. You will learn about working with color, painting with acrylics and applying mediums and collage materials. In addition, you will find cool paper clay project ideas, painting and collage techniques, and framing tips.

The entire experience of working with paper clay and finishing it can be a meditative, yet enlivening process. You will discover a newfound freedom with art making because this process is a very flexible and forgiving one. Anything can be changed, reworked, patched, added to, removed, repaired and repainted. So relax and have fun with it. Let your creative spirit guide you and get out of your own way!

STAY AT HOME DAD
Paper clay and mixed media
on canvas
12" × 9" (30cm × 23cm)

 # Tools for Clay Work

Creative Paperclay

Creative Paperclay® is the brand of clay that I use in my clay work process. It is an air-hardening modeling material that requires no firing or baking and comes out of the package ready to use. It is clean, nontoxic, odorless, dries with minimal shrinkage and is fairly durable when varnished. Plus, when wet, it sticks to almost anything without the use of glue, making it ideal for bas-relief work. You can purchase the clay in 4, 8 and 16 ounce packages. Most step-by-step projects in this book will require about 2 to 4 ounces of clay. Creative Paperclay is available in most craft and art supply stores as well as online.

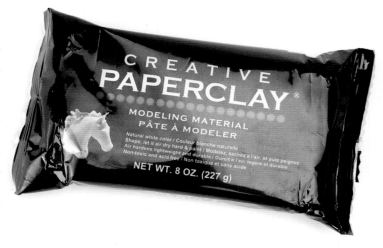

Other Air-Hardening Clays

Though I use Creative Paperclay and am most familiar with using it for this process, there are other clays that work in a similar way, such as La Doll modeling clay, La Doll Premier Light Weight Stone Clay and Fimo Air Basic. For my descriptions about each of these alternative clays, see the resources section on page 140.

Wooden Sculpting Tools

Though there are many kinds of tools for clay modeling, I use one kind of tool for most of my work, a simple wooden sculpting tool. Wooden tools glide over the clay more easily than plastic ones and have a more natural feel. Plus they can be cut and sanded to be smaller, sharper or smoother depending upon what is needed. The shape, which includes an angle with a point, is very important for sculpting bas-relief on flat surfaces. Commercially, my preferences are the models JA22 and JA24 wooden tools made by Kemper Tools. They are relatively inexpensive and if you buy two or three,

you can customize them to suit your needs. Because they are all handmade, they will vary a bit in shape. Sand them with fine-grain sandpaper to be sure they are smooth and that the angled edge is sharp. See more about how to sharpen and customize your tools on page 29.

Other Modeling Tools

Plastic, rubber and silicone clay modeling tools are great for shaping, making detail marks and cleanup work. There are several synthetic-tipped modeling tools available on the market that range from hard and firm to soft and flexible. They yield a variety of effects and are generally more expensive than wooden tools. Art supply and craft stores often carry sets of clay shapers made from rubber or silicone that work well for bas-relief. For detail work and cleaning up edges and backgrounds I use a hard rubber-tipped tool called a Wipe Out Tool by Art Advantage.

Custom Clay Modeling Tools

Years ago, I bought the perfect hardwood clay modeling tool at an art supply store, but it is no longer manufactured. I asked a wood craftsman to replicate it, and it is available on my website. To learn more and purchase, visit rogenemanas.com.

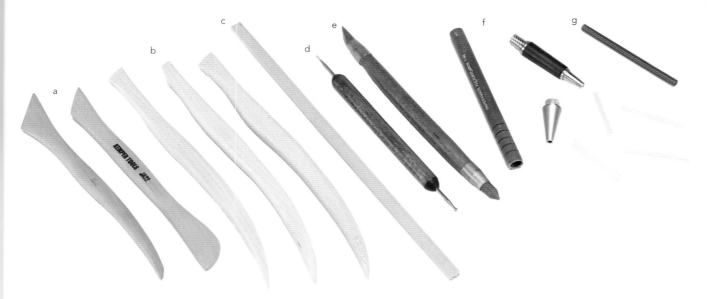

Imprinting Tools

I use a variety of commercial products and household objects for making details, textures and impressions in the clay. I have a container of odds and ends collected from my studio, kitchen, home and garden to get the results I need, including straws for making scallops or feathers, tiny paintbrush covers or ballpoint pen parts for making bird eyes or beading, and a toothbrush for making rocky texture. One recommended tool for making dots on and embossing dry clay is a Kemper Double Ball Stylus embossing tool.

Stamping Tools

You can use a variety of items for stamping decorations into the clay. Both rubber and metal lettering stamps work well for adding words. Decorative rubber stamps with simple deep designs also work well. Foam stamps work great but tend to be on the large side. There are a lot of clay stamps available at places that carry earthen clay supplies. I sometimes carve my own stamps using a Speedball Linoleum Cutter, craft knife blade and carving blocks. You can also use items like jewelry, buttons and charms to make imprints or to make molds.

Clay Sculpting and Imprinting Tools

There are lots of clay modeling tools on the market, but I keep it simple by using a few inexpensive commercial tools as well as some household items.

a wooden modeling tools
b custom wooden modeling tools
c chopstick
d double ball stylus embossing tool
e silicone Wipe Out tool
f ballpoint pen disassembled into parts
g coffee straw

Plastic or Wax Paper

Plastic sheeting or wax paper is necessary to keep the clay from sticking when rolling it out. I like to cut up clear plastic bags like dry-cleaning bags or plastic storage bags. Any plastic bag will work, but clear is best so you can see how your clay is rolling. The thicker the plastic, the fewer wrinkles will form when rolling the clay. Wax paper also works well but is not very reusable. I use sheets that are about 12" × 24" (30cm × 61cm). See the Toolkits on page 11 for a more comprehensive list of basic supplies to keep on hand when working with clay.

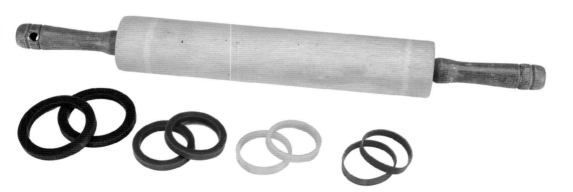

Rolling Pin and Bands

You can buy rolling pin bands that will help make your slab all the same thickness. The silicone rings slide onto your pin to keep it evenly spaced above the rolling surface.

 # Tools for Finishing Techniques

Acrylic Medium

Acrylic medium is the clear polymer base from which acrylic paint is made. This clear medium can be mixed with paints to help them flow better and increase their transparency, or it can be used by itself as a protective layer and varnish. It can also be used as glue for lightweight collage papers. For clay work, I use two kinds of acrylic medium: gloss and matte. For my finishing process, it is important to use quality mediums. Student-grade mediums may not perform as needed because they may have less polymer in them.

Gloss Medium

Gloss medium creates a durable separation barrier between the clay and the acrylic paint, which is very important for the paint removal process. It is the clearest type of medium as it has nothing in it to dull the finish. When applied over acrylic paint, it makes colors appear brighter and deeper and dries to a shiny finish.

Matte Medium

Matte medium is the coating I use on my finished pieces. It dries to a very low-luster matte look. This medium contains substances in the polymer to reduce shine. It is best applied in very thin coats. If you are not careful, matte medium can pool in corners of your work and dry to a milky finish.

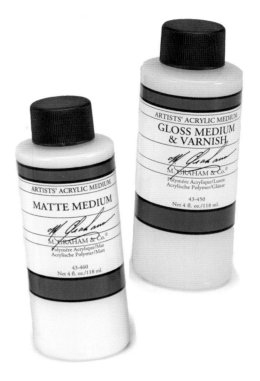

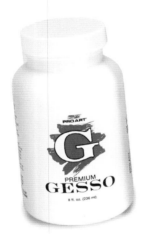

Gesso

Gesso is an acrylic compound used to paint over paper clay work to seal it, prepare it for painting and protect it from moisture. I always use white gesso for this, but colored gessoes are also available. Choose one that moves when you shake the bottle. If it is too thick, you will need to thin it, and that can affect its viscosity.

White Glue

I use a simple white glue like Elmer's Glue-All to adhere clay pieces and make repairs. Elmer's School Glue is great for collage work because it is water-soluble. Therefore if I don't like the way something looks, I can moisten and remove it. Plus it will wash out of a brush even if it dried while using it. When my collage work is complete and I am happy with how it looks, I paint over it with a clear layer of acrylic matte medium to seal it and make it permanent.

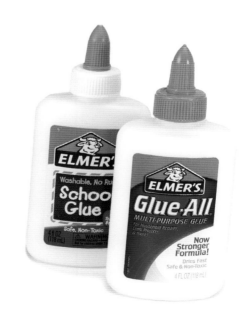

Acrylic Paints

To add depth and color to clay work, I like to use professional quality acrylic paints that come in tubes because they are thicker than bottled paints. You can always thin down tube paints with water or acrylic medium. There are many quality brands available with rich pigments. I use mostly acrylic paints by M. Graham & Co. because they are quality paints at a good price with a heavy pigment load. Student-grade or beginning level paints have less pigment and may not give the best results. Always buy the best paints you can afford.

You can get a wide range of colors from just a few basic acrylic paints. Acrylic colors come in opaque, semitransparent (or translucent) and transparent, which is usually printed somewhere on the tube of paint. You will use a mixture of all three. If you do not already own some acrylic paints, you can find a list of the paints plus a few other key colors on page 10.

Palette

I use a small sheet of glass as a palette for my acrylic paints because it works well and is easy to clean. You can moisten dried paint with a spray bottle, and it will come off easily with a putty knife or a paint scraper. You can throw the dried paint scrapings in the garbage, saving them from going down the drain. Tape the sharp edges of the glass on all sides with thin strips of duct tape.

Rubbing Alcohol

I use rubbing alcohol to remove dried paint from clay work. Rubbing alcohol, or isopropyl alcohol, is the safest solvent to use with acrylic paints. Choose 70% solution for the best results with the least fumes.

Protective Gloves

It is important to protect your hands when working with rubbing alcohol and paint. Any household rubber or latex gloves will work, but a snug fit works best.

Brushes

Painting with acrylics can be hard on brushes because they are constantly in water and if not cleaned properly, they can be easily ruined. Choose a few good brushes that are made for use with acrylics and wash them with soap or brush cleaner and water after each use. Because the projects are on the small side, the brushes used for painting them are also small. Here are the four basic kinds of brushes I use for painting the clay work projects in this book:

1) Use a broad, soft brush for applying gesso, medium and paint overall. These do not need to be expensive brushes, but must be good soft brushes that do not lose hairs. If you have old watercolor wash brushes, they will work well too.

2) Use medium-size brushes for general painting like nos. 2, 4 or 6 filberts, flats or brights. I love Connoisseur Pure Synthetic brushes because they are sturdy yet pliable and hold their shape over time. I call these my "workhorse brushes" because I use them for everything.

3) Use small brushes for fine detail work, such as nos. 2 or 3 synthetic rounds or nos. 00 or 000 sable mix rounds. It is worth the money to invest in at least one good detail brush that can hold a point. Do not leave this brush sitting in water or you can permanently bend the end and ruin the point.

4) Stiff bristle brushes such as no. 4 flats, brights or filberts are good for softening hard edges, adding soft shadows and blending colors.

Brushes for Finishing Clay

Here are some examples of brushes I use to paint my clay work:

a no. 00 sable mix round (for details)
b no. 2 Taklon round (for details)
c no. 2 stiff hog bristle filbert
d no. 2 synthetic filbert
e no. 4 synthetic flat
f no. 6 synthetic flat
g no. 4 stiff hog bristle filbert
h 1-inch (25mm) soft bristle wash
i 1-inch (25mm) hake wash
j 1-inch (25mm) Taklon square wash

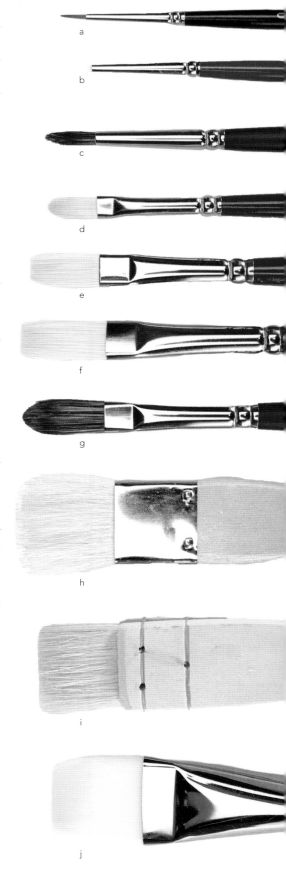

 # My Acrylic Palette

Here are the colors I use to paint all the projects in the book as well as a few additional colors you might use in a more complex palette. All of my paints are M. Graham & Co. with the exception of metallic gold, which is made by Golden.

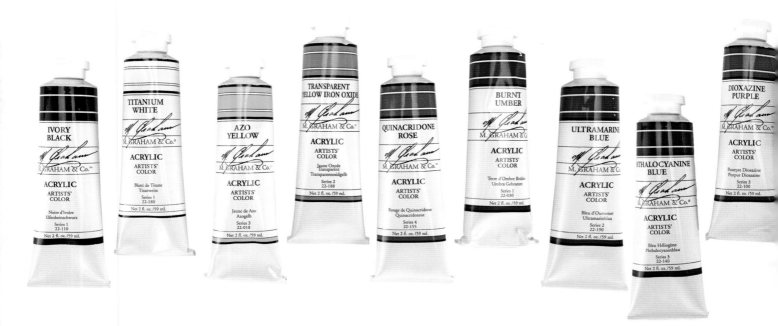

	generic color	paint name	opacity rating
colors used in book	white	Titanium White	opaque
	black	Ivory Black	opaque
	cool blue	Phthalocyanine Blue	transparent
	cool red	Quinacridone Rose	transparent
	warm red	Cadmium Red	opaque
	cool yellow	Azo Yellow	semitransparent
	warm yellow	Cadmium Yellow	opaque
	brown	Burnt Umber	semiopaque
	green	Hooker's Green	transparent
	metallic gold	Golden's Iridescent Gold	translucent
	antiquing color	Transparent Yellow Iron Oxide	transparent
bonus colors	warm blue	Ultramarine Blue	transparent
	purple	Dioxazine Purple	transparent
	orange	Cadmium Orange	opaque
	sky blue	Cerulean Blue	opaque

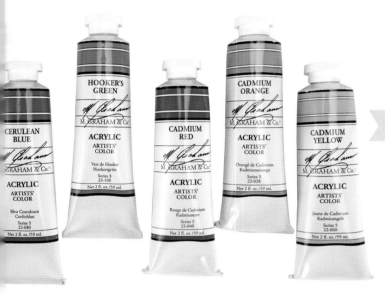

Clay Work Toolkit

Creative Paperclay
Clay modeling tool(s)
Rolling pin for rolling the clay
Plastic sheeting or wax paper
Craft knife with a no. 11 blade for cutting the clay
Small washcloth to keep your tools, hands and work
 area clean
Container of water for adhering the clay and
 keeping it moist
Talcum powder or cornstarch to keep clay from sticking
 to stamps and molds

Design Toolkit

Pencil and eraser for designing and drawing
Ballpoint pen for transferring your pattern to the clay
Permanent marker, fine or medium tipped, for inking a
 pattern
Sturdy tracing paper (around 10-lb.) for creating patterns.
 Wax paper also works well if you use a permanent
 marker to draw on it.
Carbon transfer paper for transferring your design to
 the substrate
Masking tape

Finishing Techniques Toolkit

Gesso
Acrylic medium, gloss and matte
Acrylic paints: Titanium White, Ivory Black,
 Phthalocyanine Blue, Quinacridone Rose, Azo
 Yellow, Yellow Iron Oxide, Burnt Umber, Hooker's
 Green, Metallic Gold
Brushes
Rubbing alcohol
Protective gloves
Paper towels
Containers for water, medium and alcohol
Palette
Hair dryer

Basic Toolkits

My "toolosophy" is that I like to keep art making simple and affordable. I buy quality products and use them in as many ways as possible. I would rather have a few good tools than a studio full of inferior ones. I am not fond of complicated processes that are messy, smelly or require a lot of equipment. I like simplicity, ease and results. I have invented my own way of making art and my materials list includes a lot of items you may already own.

Below I list the basic items that will get the results you will see in this book. I have combined the supplies into basic toolkits, so you can keep your supplies together for convenience to use in the practice projects and demonstrations. See page 140 for information about purchasing specific items.

Extras Toolkit

Fine-grain sandpaper for sanding dried clay, tools,
 board surfaces and edges
Spray bottle of water for keeping the clay moist
Plastic bags, large and small, for storing the clay and
 clay work
Various cardstock and mat board papers for making
 stencils
Scissors for trimming and cutting
Cutting mat or mat board for general cutting
Metal ruler for measuring, cutting and keeping things
 straight

 # Surfaces and Substrates

Paper clay will adhere to almost anything including wood, canvas, plastic, metal, glass and more. I apply it to flat surfaces to create bas-relief images that give a dimensional look to what would otherwise be rather flat. When paper clay dries, it can cause lightweight boards to warp, so it is important to use substrates that are thick enough or cradled.

Cradled Wood Panels

A cradled panel is a flat wood panel that has been cradled with a wood frame. They are strong, do not warp and are surprisingly lightweight. Their unprimed, raw wood surface can be prepared to accept virtually any art medium including oils, acrylics, encaustics and mixed-media collage. There are many available on the market. Look for a smooth surface, free of imperfections such as knots and blemishes. I like using cradled boards because I can paint the edges with a color and avoid the expense of framing my finished work.

Hardboard Panels

Hardboard is a fiberboard made from compressed wood fibers and comes in thicknesses of $1/8$" to $1/2$" (3mm to 13mm) in 4' × 8' (1.2m × 2.4m) sheets at building supply companies. They will sometimes provide a cutting service so you can have large sheets cut down to a workable size for a small fee. For panels up to 5" × 7" (13cm × 18cm), $1/8$" (3mm) is fine, but anything larger should be done on thicker material to avoid warping. Larger pieces, such as 24" × 36" (61cm × 91cm), would require $1/2$" (13mm) material to avoid warping. There are art material manufacturers that make hardboard painting panels in popular sizes. I use a hardboard panel if I plan to frame my finished piece.

Stretched Canvas

While I enjoy working on the rigid surface of wood or hardboard, I also like using stretched canvas because of its textured surface. The dried clay is slightly flexible, which works well on the canvas. You can find inexpensive, quality stretched canvas in a variety of sizes and depths that come pretreated with gesso. As with cradled panels, you can paint the edge and avoid framing your finished piece if you choose canvases that have wrapped edges (no staples on the sides). Canvas tends to be very lightweight and durable which helps when traveling or shipping artwork.

Plywood and MDO

Plywood or MDO (plywood with a smooth resin surface) is a good substrate for large paintings. It is less expensive to purchase a large sheet of material and cut it into the sizes you prefer than to buy the same sized panels at an art supply store. A building supplier will sometimes offer cutting services for a small fee. Edges may require sanding.

Mini Boards

For the practice projects in this book I use wooden boards and tags that I purchased at a craft store. I also used mat boards that I cut from larger sheets. All are about 2½" × 3" (6cm × 8cm). If they were any larger, the material would warp. Wood is more stable and less likely to warp than mat board, but both work fine for small practice pieces. If a mat board warps, use white craft glue to adhere a piece of paper to the back, edge to edge, and as it dries, it will help flatten it out. For more on mini boards see page 16.

Repurposed Substrates

I have applied paper clay to a variety of surfaces with great success. As I mentioned earlier, it will stick to almost anything including wood, plastic, ceramics, glass and metal. You can transform a plain object into a work of art with a little ingenuity and experimentation. Test the surface by adhering some clay to it and letting it dry. Roughing the surface with fine-grain sandpaper helps make the surface more porous. If the clay sticks well, it should work fine. I like finding wooden things like trays, bowls and boxes at thrift stores to transform into gifts.

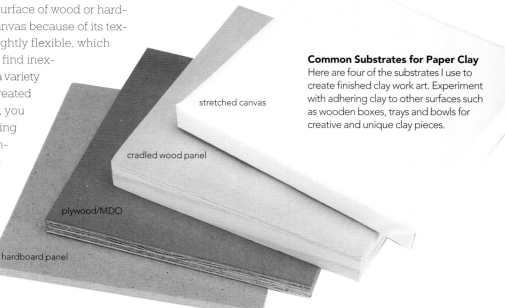

stretched canvas

cradled wood panel

plywood/MDO

hardboard panel

Common Substrates for Paper Clay
Here are four of the substrates I use to create finished clay work art. Experiment with adhering clay to other surfaces such as wooden boxes, trays and bowls for creative and unique clay pieces.

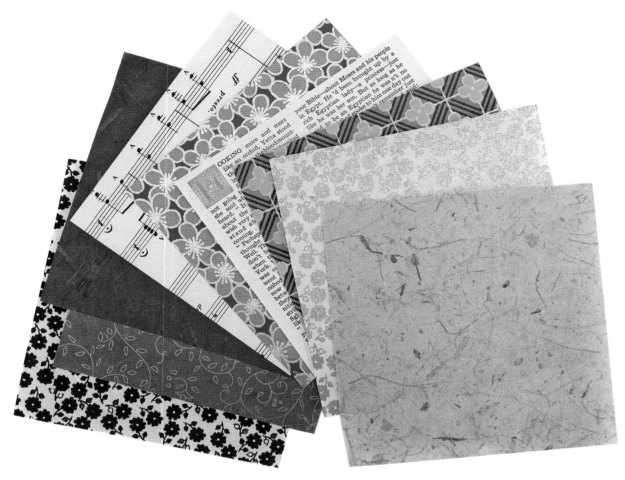

Assorted Collage Papers
Decorative fibrous papers, tissue paper and book pages are great for adding collage detail to your clay works.

Collage Papers

The project on page 118 requires a few papers in various colors and patterns to use for collage. My favorite papers to use for this work include natural fiber papers like lokta and cotton rag in solid colors and decorative patterns. These papers have color all the way through them and are usually available at art supply stores.

Cover stock papers such as those used for scrapbooking are not a good choice for this kind of work as they are too thick and have a white core, so you end up with lots of unwanted white edges. Shiny gold and silver joss papers used in Asian celebrations can be found at Asian markets. It is thin, paper-backed metallic foil that is easy to tear and adds wonderful accents to collage work.

On page 133, I demonstrate a collage papering technique using colored tissue paper from a rainbow pack of twenty colors. If you choose paper that is not colorfast, it is best to spray your final art with an acrylic conservation varnish that will protect it from UV and fading. Krylon has several choices and finishes that are available at art supply stores and online.

The Importance of Gesso

An essential step for all clay work is to coat the surface of every board or canvas with gesso. If it is wood, it may first need sanding with fine-grain sandpaper. For an extra smooth surface, paint one coat of gesso and sand it before applying a second coat. It all depends upon the feel of the surface. Substrates that are pretreated with gesso do not need to be coated, as they are ready to use.

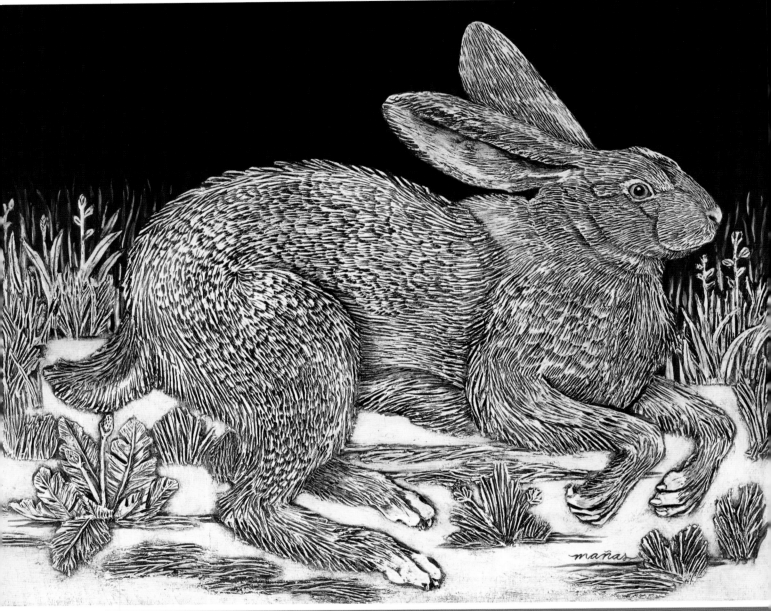

HIGH TAILING
Paper clay and acrylic on
wood panel
14" × 18" (36cm × 46cm)

WORKING
with
CLAY

1

The first section of this book will teach you all the techniques and tips I have learned and developed in working with paper clay for creating bas-relief artworks. You will find several practice projects that start with simple techniques and progress to more challenging ones. If you start at the beginning and work toward the end of this section, you'll have learned all the skills needed for the five clay projects in section 2. In section 3, we discuss various techniques for finishing your clay projects with paint, collage and mixed media.

Getting Started with Creative Paperclay

For years Creative Paperclay has been used to sculpt dolls, figurines and other three-dimensional work. It adheres to armatures made from just about anything, is easily worked and holds fine detail well, making it popular with sculptors and doll makers.

This versatile clay comes out of the package ready to use and will stay moist and workable for about 4 to 6 hours in moderate climates. You can moisten it with a little water on your finger or a spray bottle if it starts drying out before you are finished working with it.

Creative Paperclay is water-based and is quite moist when it first comes out of the package. At this stage, it is best to form basic shapes, leaving detail work until the clay begins to dry out and firm up a bit. New users often judge the clay in this wet state, thinking it is too soft and difficult to sculpt. But trust me, as it dries, it becomes more and more workable.

Paper clay adheres easily without glue to wood, canvas and most surfaces. Simply smear the surface with water and press the clay to it. When dry, it's similar to a soft wood in that it can be sanded and carved, and is fairly durable and lightweight.

When paper clay is adhered to a flat surface, it can be sculpted into a shallow relief, or bas-relief, adding another level to two-dimensional work. The final result is a wood-carved effect that leaves people wondering how it was made.

Throughout this book, when I refer to paper clay or clay, I am referring to the brand Creative Paperclay. The alternate clays listed on page 140 might work in the same way, but I have not tested them in every instance.

About the Practice Projects

Practice makes perfect. And working with paper clay takes a little practice. Before you launch into any of the step-by-step projects in section 2, it is a good idea to work through the techniques in this section. These practice projects are completed on mini boards coated with gesso. If you practice each technique you will end up with several little clay works of art that you can use to practice the painting techniques demonstrated in section 3. Even though I demonstrate only a few ways of using the techniques, I encourage you to experiment with your own ideas for applying them.

Gather Your Materials
For the practice projects in this section, you will need the Clay Work Toolkit featured on page 11, a selection of mini boards prepared with gesso and cardstock for creating stencils.

Mini Boards
You will need to prepare your mini boards with at least two coats of gesso to create a good ground for clay work. Though paper clay will stick to just about anything, gesso seals the substrate and provides a stable and porous ground that the clay will adhere to well. Learn where to purchase mini boards in the resources section on page 140.

Rolling

For all the projects in this book you will begin by rolling out a slab of paper clay. Paper clay that is fresh from the package is often wet and sticky. It will begin to dry and firm up as you work with it and become easier to manipulate.

When opening a new bag of clay, cut the top off the bag carefully. The original bag is the best container for keeping your leftover clay moist for the longest time. Tape the package closed to keep the rest of the clay from drying out. It also helps to keep the original bag inside another sealable plastic bag for extra security.

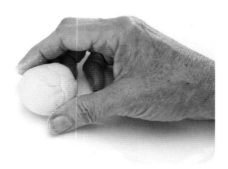

1 Place a piece of plastic sheeting or wax paper on the work surface, letting the end drape over the edge of the table. To keep the paper from slipping, wet the work surface with water before placing the bottom sheet down. You can also tape the bottom sheet down. Take out a golf ball sized piece of paper clay.

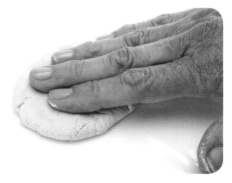

2 Flatten the ball of clay into a pancake shape.

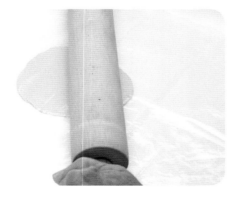

3 To keep the clay from sticking to the table or the rolling pin, always roll it between two sheets of plastic or wax paper. Lean against the table edge to hold the plastic in place and gently roll the clay away from you. Turn the clay as needed to help roll a consistent thickness. You can lift the clay and turn it or turn the sheeting. Roll gently until you make a slab the thickness of a pie crust, about $1/16$" to $1/8$" (2mm to 3mm) thick.

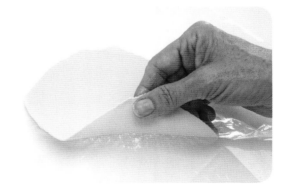

4 Once the clay is the right thickness, lift it gently from the sheeting and place it back on a clean area of the plastic for cutting. Always wipe your sheeting clean for future use. Dried clay particles left on the plastic can make a mess of your work area if you don't wipe them away. Sometimes the clay is very wet or you press too hard, and it sticks badly to the sheeting. If this happens, scrape it, wipe off your sheeting and begin the rolling process again.

Cutting

Because paper clay will stick to just about anything, it will want to stick to your cutting tool. Use a sharp, clean craft knife and a scoot-scoot-scoot method of cutting, rather than trying to drag the knife in one smooth stroke. Dip the blade into water to help it glide through the clay if needed. A kitchen knife or box cutter type of craft knife is too blunt and awkward for this kind of work. Be careful not to press too hard, or you may cut your sheeting.

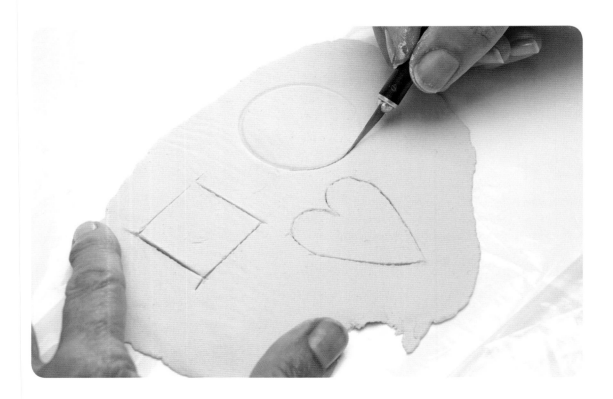

5 Using a clean, sharp craft knife, cut the clay into a heart, a circle and a square about 2" (5cm) across. Note that the cuts are angular and kind of rough. Use templates if you like, such as a paper cutout for the heart shape or a jar lid for the circle. Or simply cut them freeform. Peel away the excess clay, leaving your three shapes: a heart, square and circle. Keep your leftover clay scraps covered with the plastic while you are working the clay. Wipe your craft blade clean to keep dried clay bits from building up.

Placing

Perhaps the question that I am asked the most is "How do you make the clay stick to the board?" The truth is, paper clay sticks easily to wet surfaces. So you will always wet the surface of your substrate with water before placing your clay on it. If your clay is not sticking down well, it is likely because you are not wetting the surface enough or pressing down enough. If, after placing your clay, you see air bubbles trapped underneath it, prick them with your craft knife blade or a pin, then press down and use your clay tool or finger to smooth the surface.

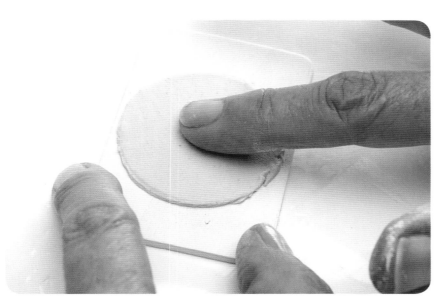

6 Wet your finger in the water and smear the surface of the mini boards where you plan to place your clay. Be sure it is "shiny wet." Place the cutout of clay on the wet spot. Gently press the clay to the surface with your fingers. Be sure all edges are pressed down. Repeat this with the other shapes.

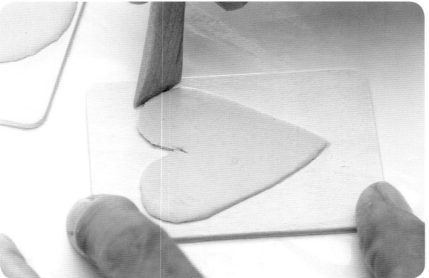

7 With the wooden clay modeling tool and your finger dipped in a bit of water, smooth along all edges of each shape. You may need to reform each shape a bit with your modeling tool. You can smooth the top of each shape with your finger or the clay tool as needed. The edges of the clay will dry out first, so always smooth the edges before you continue working the clay.

Shaping

When the clay is placed, it's time to practice using your clay modeling tools. As you work the clay, you will get a sense of how easy or difficult it is to create detail. When the clay first comes from the package, it can be very wet, soft and sticky. When it is wet, it is best for rolling, adhering to the boards, smoothing edges and forming basic shapes. But when you let it sit for a short while, the clay will dry out a bit, becoming more firm and better for adding detail.

If needed, you can use a tiny bit of water on your finger to smooth the clay, but always take care not to make the clay surface too wet. For this reason, it is practical to work on a few projects at a time. While one is firming up, you can work on another.

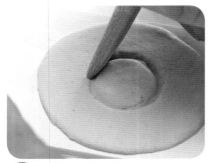 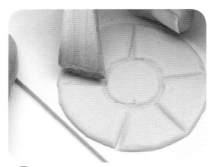 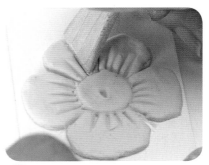

8 To make a simple flower out of the circle, use the clay tool to form a center circle.

9 Press the tool into the clay to create spokes radiating out from the circle.

10 Cut away little triangles at the end of each spoke to create five petals. Round the edges of each flower petal with the modeling tool and decorate the petals and center circle as you like.

Become Familiar with Your Clay Modeling Tool

Your clay modeling tool may be the most important tool you will use to create bas-relief images, so it is important that you become friends with it. It is the best tool for smoothing, shaping, marking and sculpting the clay. It is natural to want to use your finger dipped in water to smooth the clay. But that makes the surface wetter and it will need to dry out before you can add detail. Practice using your tools especially for smoothing the surface of your clay. For surface smoothing, use the angled edge of your tool and gently stroke it across the surface of the clay at about a 30-degree angle.

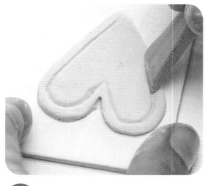

11 Switch to the heart shape, and draw a smaller heart inside. It helps to scoot your tool to make a line and then smooth the line with a second stroke.

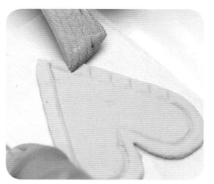

12 To embellish the border, use the angled side of the tool to press into the clay.

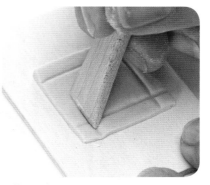

13 Add a square frame in the center of your square to divide up the space.

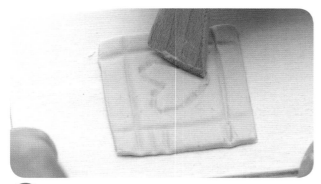

14 Add a decoration to the center like a simple heart.

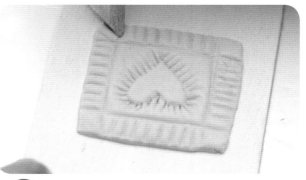

15 Simple strokes can embellish the corners and sides.

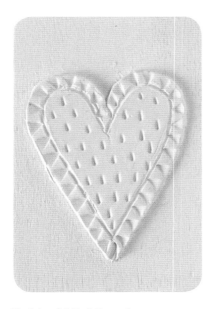

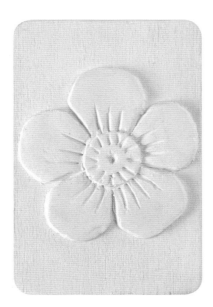

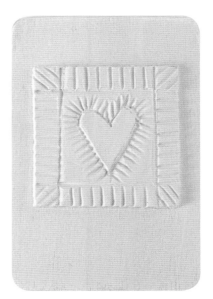

Finished Mini Boards

Here are the completed clay practice projects. Turn to page 80 to learn how to prep them for painting and other cool finishing techniques.

Imprinting with Household Objects

In addition to your clay modeling tool, there are countless ways of imprinting the clay with an array of tools found around the house. Whether the tines of a fork, a toothpick, a bottle cap or a straw, all can make interesting and useful impressions. Here are a few simple ideas for creating detail in your clay works:

- Take apart ballpoint pens to make tiny circles for birds' eyes or flower centers
- Use a straw to make scallop shapes for feathers or fish scales
- Try a toothpick or bamboo skewer to makes tiny dots
- A toothbrush makes great texture for rocks and sand
- The square end of a chopstick can make useful rectangular shapes

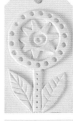

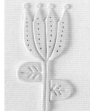

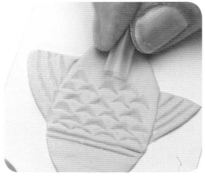

1 Cut a simple fish shape from a slab of rolled out clay with a craft knife. Place it on a mini board and shape it with your clay tool, being sure to smooth the edges.

2 Add detail strokes including the fins and tail. Use a piece of a straw to create scallops by holding it at a low angle in order to best see where you are imprinting. Use the tip of a ballpoint pen to imprint the eye of the fish.

Finished Mini Boards
These mini boards were made by cutting, placing and shaping the clay, then imprinting them using odds and ends. This is a great technique for a simple, modern look.

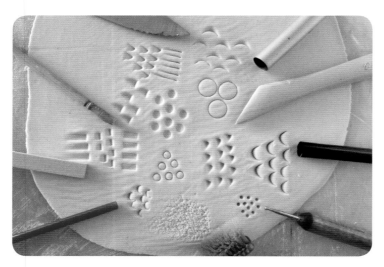

Creative Clay Details
To create interesting, unique textures, experiment with items from around the house such as an old toothbrush, a knife or the end of a straw or pen.

FLOWER POWER
Paper clay and acrylic
on wood panel
12" × 9" (30cm × 23cm)

This entire piece was made using my clay tool, craft knife and various household objects for imprinting. It is a combination of simple shapes and basic imprinting techniques. To make the surface extra smooth, I sanded as needed with fine-grain sandpaper after the clay had dried. Sanding works well if you have created deep impressions in the clay otherwise you might sand off your imprints.

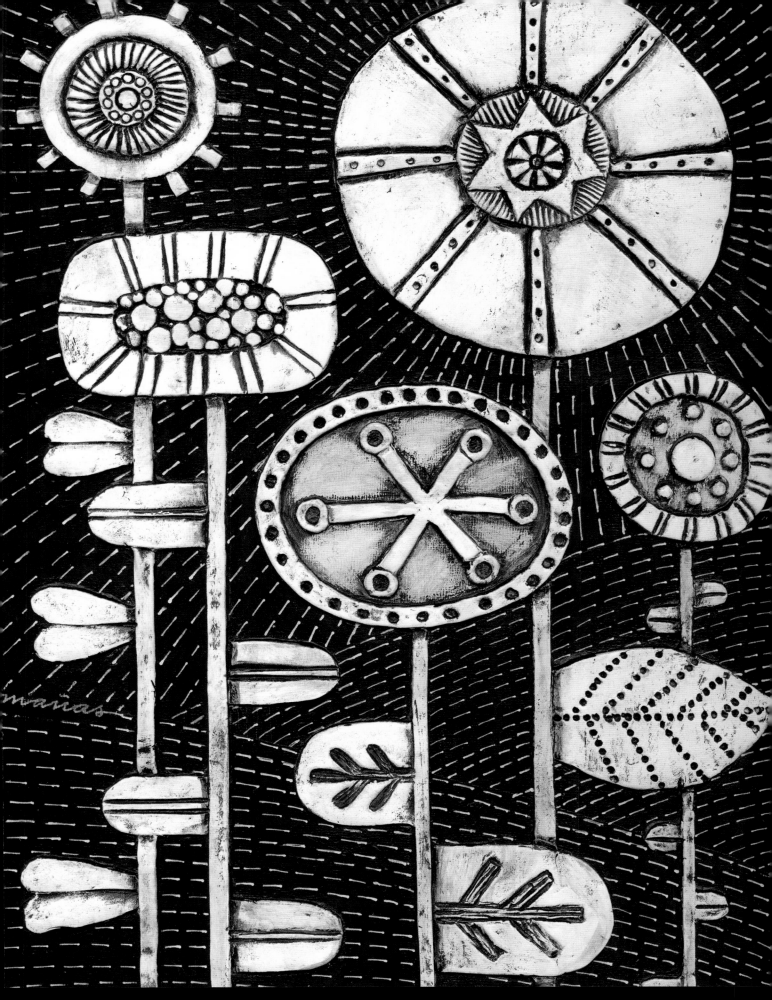

Imprinting with Stamps

There are many kinds of stamps and cutouts you can use for imprinting the clay. Commercial rubber stamps can work well, but some may be too shallow or too detailed to make good impressions. Foam stamps and wooden fabric stamps can work well with their simple and deep designs. You can also make your own stamps using carving blocks to create simplified designs that are deeper than most rubber stamps.

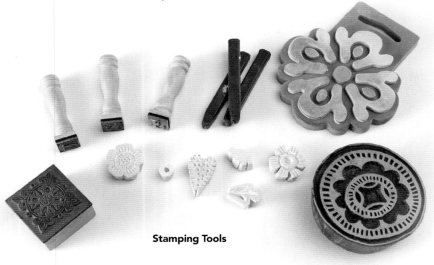

Stamping Tools

1 It is good to practice stamping before you start imprinting on your work. Roll out a quick practice slab and try out your stamps to see how well they work and how hard to press to get a good imprint.

2 Prepare a mini board by placing clay in the middle of the board and pressing it down well (be sure to always smear with water first). Make sure the clay is larger than your stamp and well adhered to the board or it can lift when stamping. Smear the surface of the clay with talcum powder to keep it from sticking to your stamps and stencils.

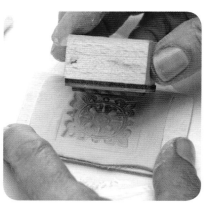

3 Place your stamp and press down on all edges to be sure a good impression is made. Carefully lift the stamp.

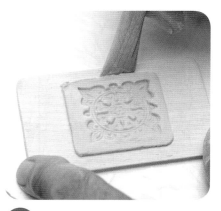

4 Trim the edges with a craft knife to remove excess clay as desired. Smooth the edges of the shape with your clay tool.

Make a Custom Stamp

You can make your own stamps using paper clay and objects like pendants, wooden ornaments or charms. Simply make the impression and let it dry. You then have a reversed image to use as a stamp that will yield an impression similar to the original item, convex instead of concave. Select items that have distinct forms and details.

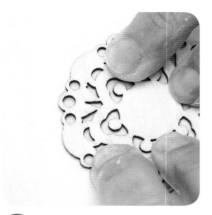 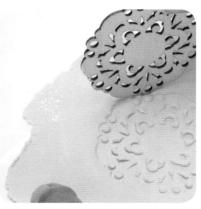 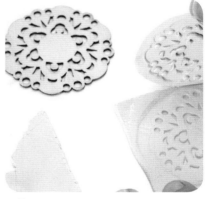

1 To make your own stamp, roll some clay to about ¼" (6mm) thick and lay it on plastic after lifting it. Smear talcum powder on the surface and imprint an object into the clay, being sure to press all edges evenly.

2 Being careful not to disturb the impression, lift the object from the clay. If you like, you can cut around it with a craft knife to make a clean stamp. Allow it to dry completely (see page 34 for more on drying methods).

3 Once your mold is dry, you can use it as a stamp. Always make sure to smear talcum powder on the clay before stamping it so the stamp doesn't stick.

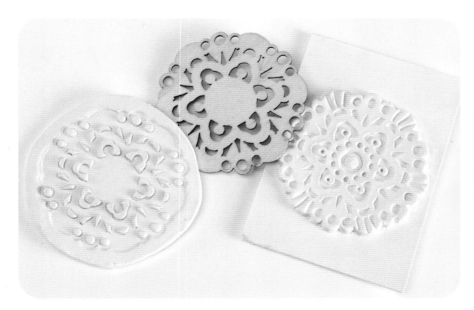

Finished Custom Stamp and Mini Board
On the left is the dried homemade clay stamp with trimmed and sanded edges. On the right is a finished and embellished mini board created with the stamp. Remember to smear water on the mini board before placing the stamped cutout on it.

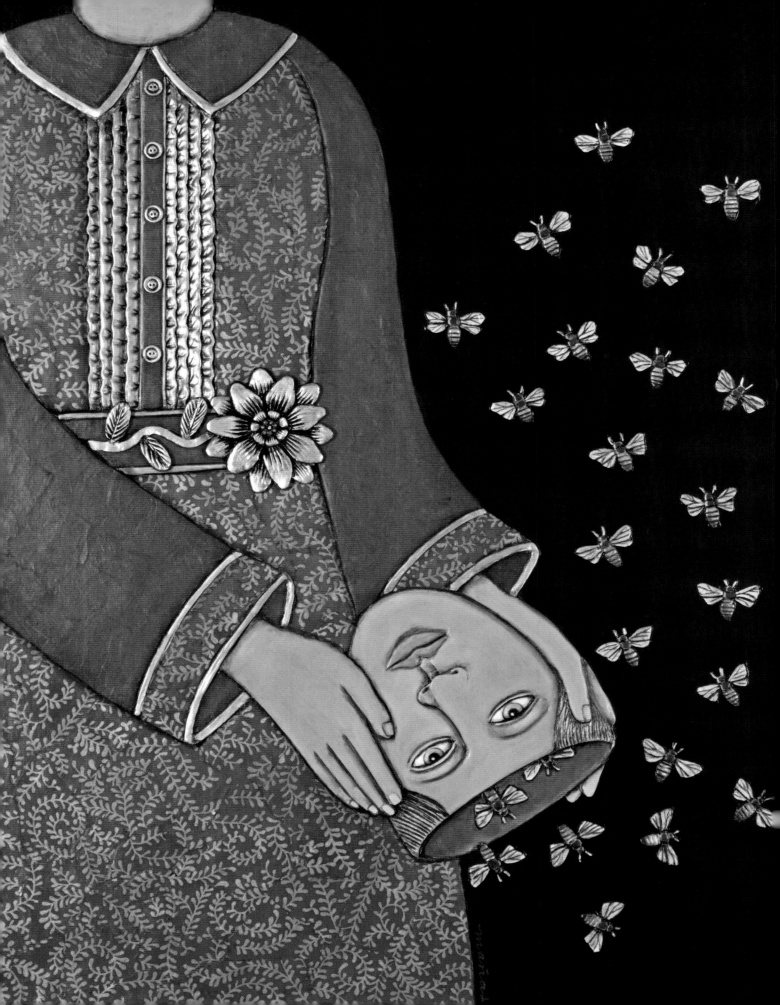

Imprinting with Stencils

A great way to add a shape detail to the surface of the clay is by cutting a paper stencil from cardstock, tag board or mat board, depending upon how deep you want your impression. You can also use the negative shape as a stencil. It is very useful when making repetitive images, such as the bees in the artwork on the facing page. The cutout can give a consistent shape and you can easily add detail.

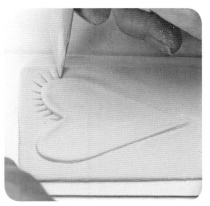

1 Cut a heart from a folded piece of cardstock. Press some clay onto a prepared mini board and smear the surface with talcum powder (see step 2 on page 24). Place your stencil on the clay and firmly press it down with your fingers and clay tool.

2 Carefully lift the stencil. By using a reverse image to imprint with, you create a raised heart rather than an indented one.

3 Trim away the outer edges and embellish the heart with your clay tool. Continue adding details as desired using other unique tools.

MORE UNWANTED THOUGHTS
Paper clay and mixed media on wood panel
24" × 18" (61cm × 46cm)

Stencils are a great way to create repetitive shapes. In this piece, I used a stencil of a bee shape to impress into the clay. I then cut out the shape, placed it on the board, and added detail. This way, all the bees are about the same size and shape.

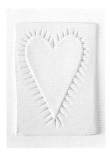

Finished Mini Boards
Here are a few examples of completed mini boards made using stamps and stencils.

Sculpting the Clay

Up until now, we have primarily used simple methods to shape, mark and imprint the clay. They are all useful ways to make art, but working with your clay-modeling tool to sculpt in bas-relief is by far the most versatile method.

Bas-relief is a term for a shallow sculpture giving the impression that the sculpted material has been raised above the background plane. Normally, this work is done by chiseling or cutting away the surface matter to create deeper levels, thereby making the top layer look raised. But because paper clay adheres easily to the background plane, it can be cut, applied to the surface, formed and then sculpted. The final result looks like carving, but it is much easier to make.

The main tool used to create most of the work in this book is a wooden clay-modeling tool. The next exercise shows a variety of sculpting techniques using this versatile tool.

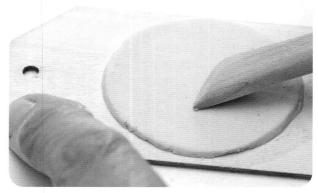

1 Cut a 2" (5cm) circle from the clay and place it on your mini board, being sure to wet the board first. Press it down and smooth the edges and the surface with a tiny bit of water on your finger and a modeling tool.

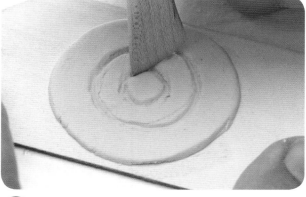

2 With your clay tool, draw a medium circle inside the larger one. And then draw a tiny circle inside of that. The outer circles will form the petals while the inner circle will become the center of the flower.

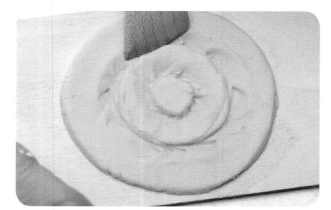

3 Using your clay tool, press down along the outside edge of each line to begin forming the flower. Turn your board as you go so you can get a good angle each time you press down.

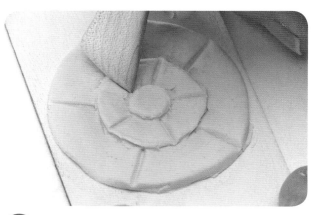

4 After smoothing the surface a bit, stroke lines radiating out from the center on each circle to indicate the petals. There is always a certain amount of reshaping that must occur because one stroke or press might undo another.

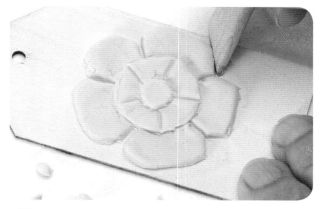

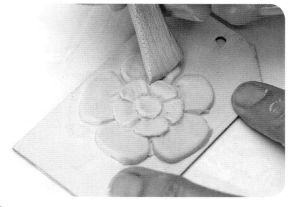

5 At the end of each spoke, cut a tiny triangle from the corner of each petal on the outer circle. Shape the ends of each petal by scooting the clay to make rounded ends.

6 Gently round the petals of the inner flower from spoke to spoke and reshape the center circle as needed.

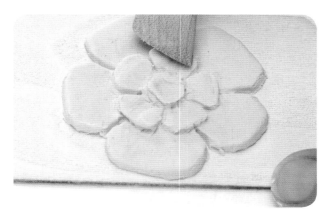

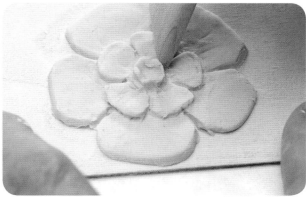

7 Smooth the tops of each petal by stroking them from the middle to the outer edge with your clay tool.

8 Form the center of the flower by stroking the clay from the base of the circle upward. This will lift the center to be taller. Reshape the petals if needed.

Caring for Your Clay-Modeling Tools

When you use your clay modeling tool often, it eventually loses its sharpness, which is needed for detail work. To keep it sharp, sand both sides of the pointed end until it is smooth and has somewhat of a knife-edge. Lay a small piece of fine-grain sandpaper on your table, hold it down with one hand and rub the tool back and forth on it with the other. Be sure to hold the tool so the side edge of the angle is in contact with the sandpaper.

You can customize wooden tools by shaping them to suit your needs. Sometimes you want the same shape but much smaller, more blunt or more pointed. Use your craft knife to carefully whittle away the end until you form a shape that works for you, then sand the sides to make them smooth.

Polishing your wooden tools occasionally with furniture wax helps keep them smooth and preserved. Once you find the tools that work best for you, treasure them!

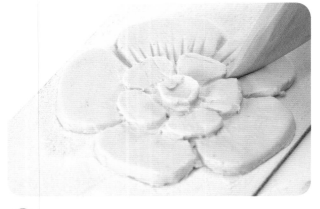 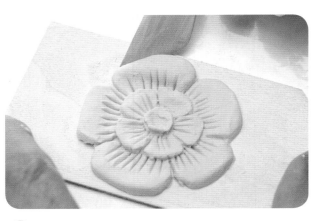

9 Now that you have been working the clay for a while, it might be firm enough to start adding detail strokes. Add strokes to each petal from the center out. When painted, these strokes will look like veins or shading.

10 Adding detail strokes may flatten the petals. You can reshape them by scooting the edges inward.

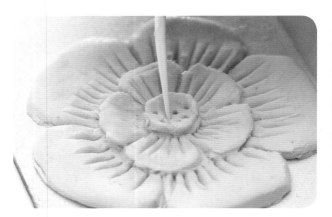 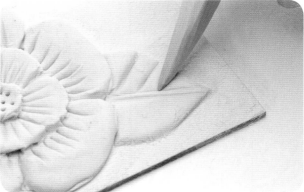

11 Add some texture to the center of the flower with a toothpick or the pointed end of your tool.

12 To form a leaf, cut a small triangle of clay and place it next to the flower, tucking it as closely as possible. Add detail strokes to it and reshape everything as needed.

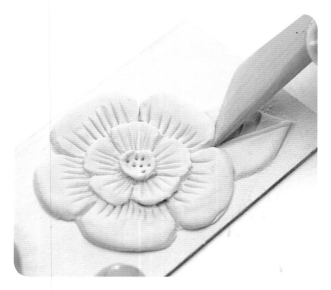

13 Add more realistic dimension to your artwork by lifting the edges of the clay. You can tuck a bit of clay under the lifted area to support it. But be careful not to lift too high or the area will be vulnerable to breaking or cracking.

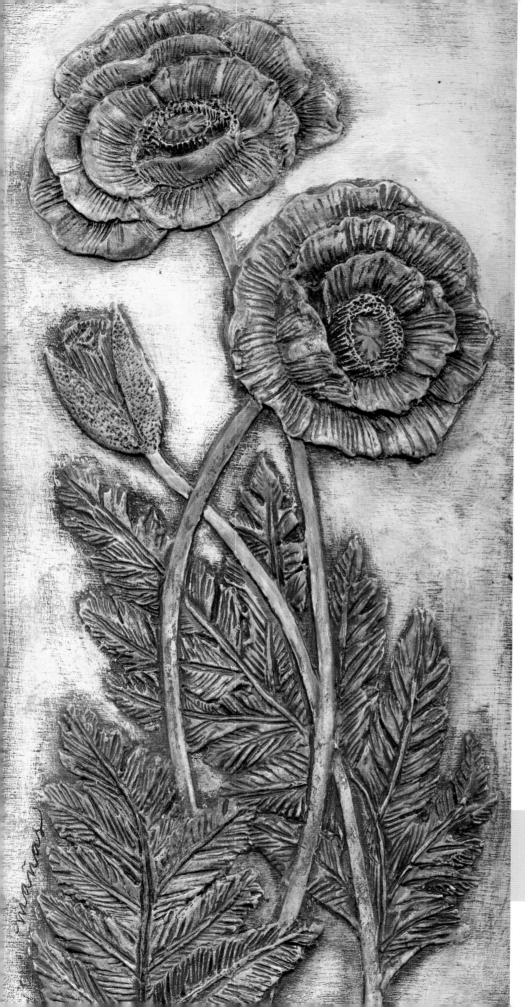

Summer Poppies is an example of sculpting in bas-relief. The clay work has been enhanced with paint and you can see the results of the detail work. Notice how there are different levels to the flower petals. The deeper areas are shaded and the higher areas are light. This enhances the shape of the object because the strokes in the clay are like strokes of a pencil. They add detail, depth and shading, especially when enhanced with dark paint, while smoother areas tend to come forward because they remain light.

Sculpting paper clay is a lot like drawing and painting. Use the strokes of your tool to define forms just as you would with a pencil or a brush. In section 3 you will learn how to easily enhance your detail work with acrylic paint.

SUMMER POPPIES
Paper clay and acrylic on wood panel
12" × 6" (30cm × 15cm)

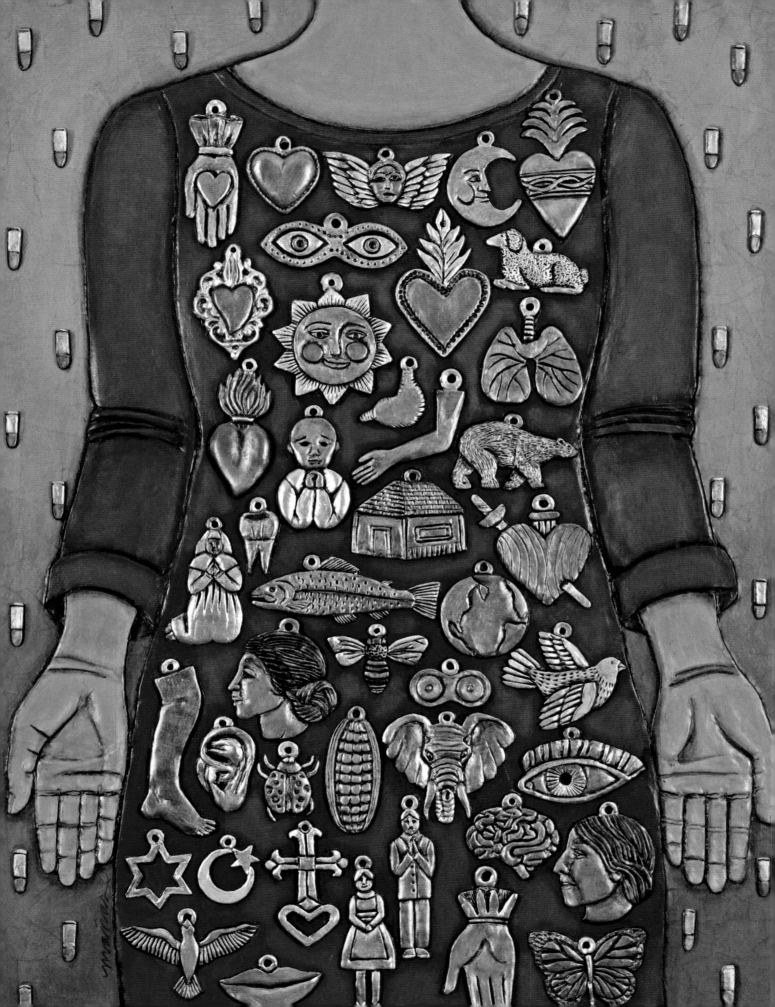

Make a Clay Appliqué

You can create small paper clay appliqués right on your plastic sheeting that can be added to artwork. Start with some simple shapes using stamping and sculpting techniques to work the clay. When done, let them dry completely and then peel away the plastic. The result is a dried piece that you can glue onto the surface of other artwork or paper clay work with white craft glue such as Elmer's.

Dried clay pieces can be fragile and are best applied to a backing such as a board or other artwork. If you use thicker clay—about ⅛" to ¼" (3mm to 6mm)—the pieces will be sturdy enough to use as package tags or ornaments without a backing. To reinforce them, you can glue on a backing of paper or felt, trimming away the excess with your craft knife or scissors. Finishing them with sealers will also help make them sturdier, as discussed on page 80.

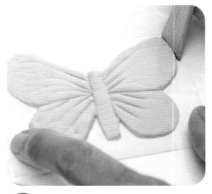

1 Roll and cut a simple shape from the clay such as a butterfly. Place the clay right on plastic sheeting and sculpt or stamp it. Tap all edges in toward the middle using your clay-modeling tool so they are nice and tidy.

2 When the clay is dry on the top, peel away the plastic from the back and turn it over to dry the underside. If you leave the plastic on, it may not dry.

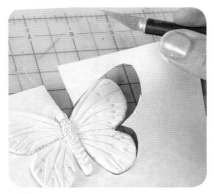

3 Glue on paper backing and trim the edges with scissors or a craft knife. You can also sand the edges with fine-grain sandpaper. When dry, appliqués can be fragile and may warp slightly. Flatten them out by putting a weight on top for a while.

IN NEED OF A MIRACLE
Paper clay, mixed media on cradled panel
24" × 18" (61cm × 46cm)

This paper clay body was formed and sculpted on the board, while all the *milagros* (Mexican miracle charms) and bullets were created as appliqués, then adhered to the surface with white glue.

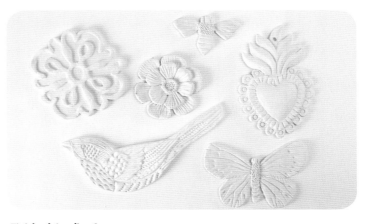

Finished Appliqués
Painting these pieces with gesso, medium or acrylic will cause them to soften slightly and you can reshape them. Add a paper or felt backing if you plan to use them by themselves. Poke a hole in the top and loop ribbon or string in the hole or between the clay and backing to make an ornament or hanging piece.

 # Drying Your Clay Work

The clay is completely dry when it is bright white and hard all over. If you see darker areas or it gives a little when pushed, then it is not dry enough to paint.

Generally, most paper clay projects will dry overnight. But if the weather is humid or wet or the clay is thick, it may take longer. Set your clay near a heater vent on a cold day or in the sun on a warm day to make sure it will be dry when you are ready to paint it.

Speeding Up Drying Times

If your board is small enough, you can slip it into an oven set at 200° F (93° C) and dry your work in less than an hour. Check it every 20 minutes. Don't make it any hotter than 225° F (107° C) or you could burn your board.

You can use a hair dryer to blast it with warm air, but be sure it is dried all the way through and not just on the surface. A heat gun tends to dry the surface while leaving the insides moist.

Repairing Dried Paper Clay

Paper clay shrinks ever so slightly when it dries. Occasionally, especially when working on large pieces, the surface may crack and split as it dries. This usually happens when the clay is thick or covers a large area. To repair a crack, simply take wet clay and press it into the crack to fill it. Use a clay tool to smooth the surface. You can also sand it when it's dry if it needs further smoothing. For extra tiny hairline cracks in the clay, gesso will typically fill them in so they will not show. See the example below for how to repair cracked clay work.

Fine-Tuning Clay Work

When your clay work is dry, it is a little like balsa wood and can be cut, carved and sanded. Here are a few ways to fine-tune your clay work:

1) Using a clean, sharp craft blade, carve away imperfections and clean up edges as needed. You can make thorns, claws, bird beaks and leaves come to a clean point, which can be hard to do with wet clay. You can also trim along the edges of things like stems and branches to slim them down if needed, being careful not to cut into your surface, especially if it is canvas. This makes working on a wooden board a clear advantage.

2) Use fine-grain sandpaper to sand the surface of anything that you want to be smooth, such as a face or a butterfly wing. And you can sand background surfaces to remove any unwanted clay bits that might be left behind. If your detail work is shallow, take care not to sand down too far. Blow or brush away the particles or they will clog up recessed details.

3) Use your clay tool to burnish the clay surface to smooth it. Do this when the clay is nearly dry. This is a subtle smoothing technique to use on things like faces, eyes, beaks, and leaves.

Reconstituting Dried Clay

Creative Paperclay can be reconstituted if it dries out completely, but it has more of a granular finish compared to fresh clay. As you work on your projects, you may end up with dried bits of clay here and there. If you keep them all in a plastic container with a lid, you can add a bit of water to cover the clay. It will reconstitute into a very soft slip. You can then dry it out a bit and knead it into usable clay. You can use it for things that do not require a smooth surface such as rocks, tree trunks and underlayers.

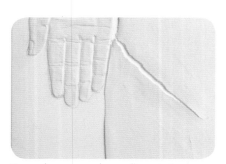
Paper clay may crack or pull apart at a seam as it dries if it is covering a large area.

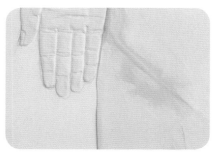
Simply fill the crack with wet clay and smooth it with your tool.

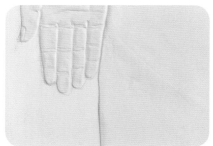
When dry, sand it with fine-grain sandpaper. Once painted, the crack will disappear.

Make a Custom Mold

You can create stamps and molds from your own clay work. It must have clean indentations that are deep enough to hold detail. Shallow marks will not work as well.

This technique is great for making a series of images that are similar such as a swarm of bees, butterflies or birds. Or if you have spent hours crafting something you love, you can make a mold from it to make more to replicate or add variations to.

To help protect your clay work and molds from moisture, paint them with thin coats of gesso. This will help preserve them for future or repeated use. See page 80 for details about sealing with gesso.

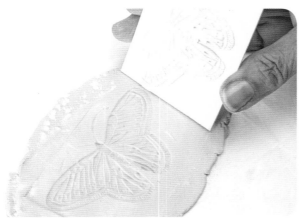

1 Create an interesting clay work on a small board or create an appliqué. Here I have created a monarch butterfly. When it dries completely so that it is hard to the touch and bright white, it is ready to use as a stamp.

Roll a small piece of clay about ¼" (6mm) thick to fit your clay work stamp and place it on a small piece of sheeting. Smear the smooth surface of the clay with talcum powder and press your clay work into the wet clay, being sure to press all the edges down evenly. Lift the clay work and trim around the edges being careful not to disturb the impression. Allow it to dry and remove the plastic from the back. This will be your mold.

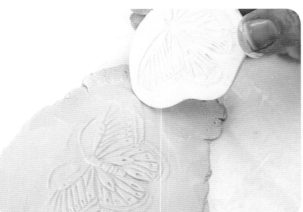

2 When the mold is dry, roll another piece of clay to fit over it. Smear talcum powder on the wet clay and press it into your mold evenly, then pull them apart to get a clay impression that matches the original. Trim the edges, place it on a mini board and use your clay tool to smooth the edges. You may have to refine and rework the design slightly, but this gives you a tremendous head start on making a clone of your original. Tiny details can be added that are hard to imprint or cut around, like butterfly antennas or leaf stems.

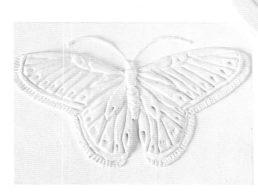

Original Sculpted Clay Butterfly and Matching Mold

Laying Wet Clay Over Dry Clay

There are times when layering the clay works best. For example, if you wanted to make a hand with a bird in the middle of it, you could sculpt the hand one day, let it dry overnight (or in the oven) and then add the bird. The advantage is that the first layer of art will be dried and you won't have to worry about messing it up as you work on the second layer. The wet clay sticks to the dried clay perfectly. Just be sure to smear some water on the surface before adding your clay.

 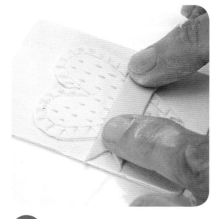 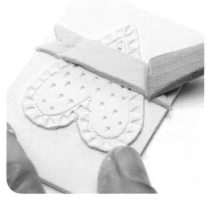

1 In this example, I want to add a little banner to the heart from the exercise on page 27. Roll some clay and cut a small strip about ⅜" (10mm) wide and 2" (5cm) long.

2 Smear some water on the bottom of the heart and on the board and place the strip on the clay work, pressing it gently into place.

3 Cut a small triangle from each side of the strip to make ribbon ends. Press the banner down to the board along the edge of the heart on both sides. Decorate it or stamp the little banner with a word or leave it plain.

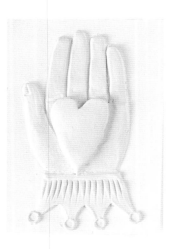 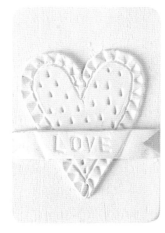

Finished Layered Clay Mini Boards
Here are a few examples of layered clay where wet clay was added to dried clay work.

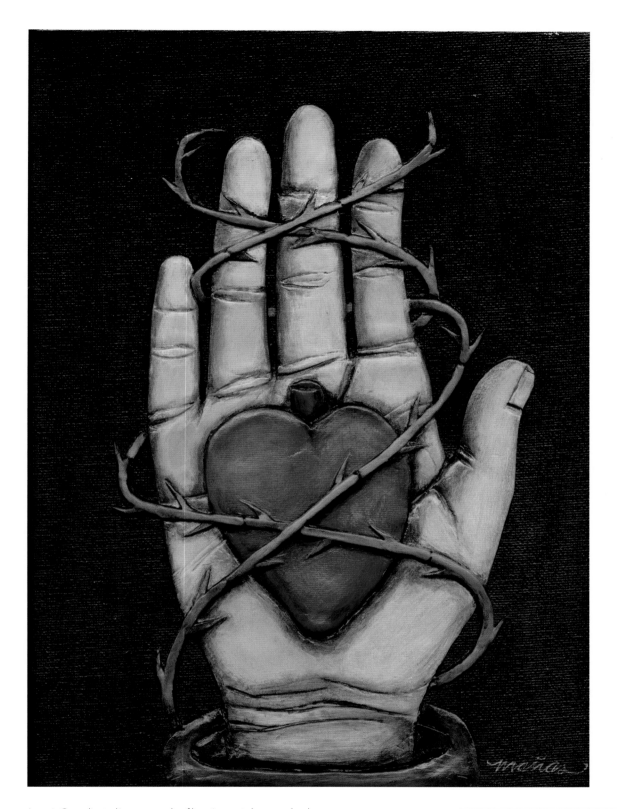

Love is Complicated is an example of layering wet clay over dry clay. I sculpted the hand and let it dry, then added the heart and let it dry. Lastly, I added the vine. Wherever the vine left the surface of the hand and went to the board, I added a bit of clay under it to fill in and hide the transition space. Otherwise you can end up with a line where the levels change.

LOVE IS COMPLICATED
Paper clay and acrylic
paint on canvas
12" × 9" (30cm × 23cm)

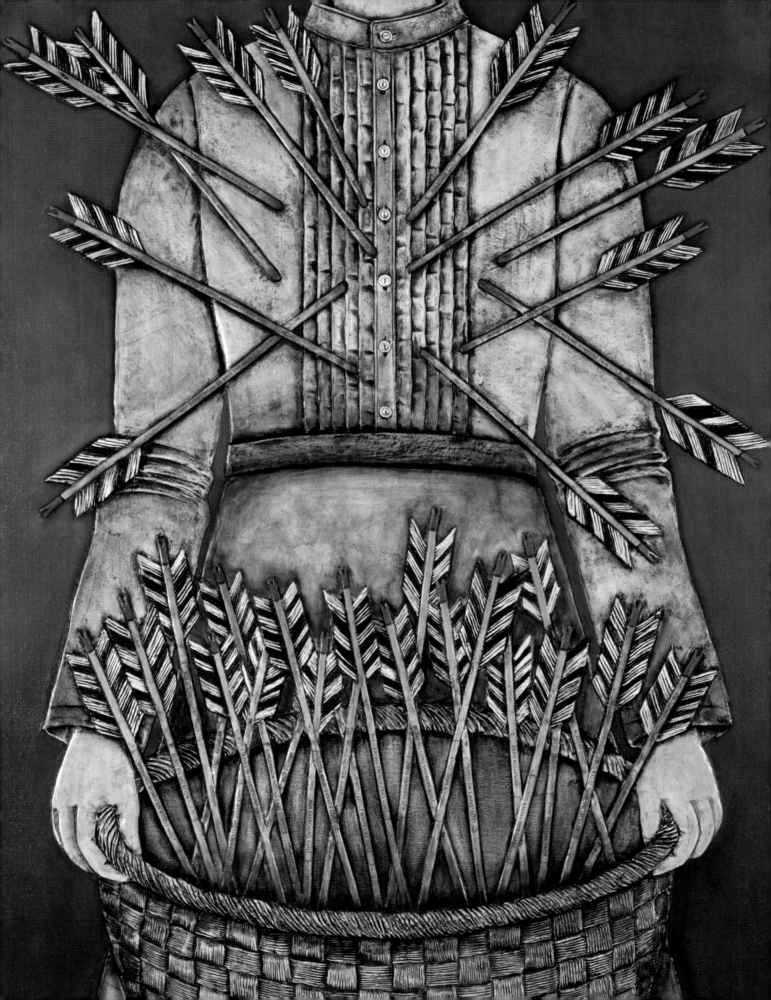

 # Keeping Your Clay Moist

Occasionally, as you work on large or complicated projects, you will want to keep your clay work wet and workable. Since the substrate will want to pull the moisture out of the clay, simply covering wet work with plastic isn't enough. Here are the steps to take if you need to come back at a later time to finish your work:

1) Moisten all the edges of the clay as they are the first to dry out. Depending upon the temperature and the dryness of your clay, you can lightly spray your entire piece with water just to be sure it is well moistened.
2) Dip a paper towel into water, wring it out and keep it in a little wad.
3) Place the wet paper towel wad on a small piece of plastic sheeting (so it does not soak into your board or canvas) and set it on your substrate. This will act as a little humidifier.
4) Cover the entire board, front and back, with plastic sheeting or a large plastic bag. Air can come through the back and dry out the clay if it is not covered with plastic.

You can keep the clay work moist for 3 to 5 days depending upon your climate and the temperature in your room. Be sure to check on your clay daily if possible. You may need to spray it again with water if it seems to be drying out too quickly. Certainly, hot, dry climates will take more moisture from the clay.

Storing Paper Clay

Creative Paperclay comes in an airtight plastic bag that can keep the unopened clay moist for years. So it stands to reason that the bag itself is a good place to store unused clay once it is opened. Tape it shut and put it in another plastic bag just to be sure. Take care when opening the bag so you can keep using it. Otherwise, a plastic resealable storage bag will work for a few months. You may even want to double up.

Keep Clay Moist Overnight or a Few Days
Using a damp paper towel as a humidifier can keep clay from drying out when you need to pause while working on it.

The clay is workable for several hours before it begins to dry. While you are working, it might start to show signs of cracking or turn white on the edges.

If this happens, wet it using your finger and a bit of water (or use a spray bottle) and smooth out the cracks using your clay tool. Just know that every time you wet the surface, you may have to wait for it to dry out to begin detail work because it could become too soft.

THE BURDEN OF GUILT
Paper clay and mixed media on canvas
36" × 24" (91cm × 61cm)

This large piece required several days of work to complete. I began by forming the figure completely except for the hands and allowing it to dry. Then I worked on the basket, keeping it moist for a couple of days while I formed and sculpted it. When it was dry, I added the hands, then a few arrow shafts at a time, sculpting each one in place and allowing it to dry. Finally I added the feathers to each arrow. Once the entire piece was dry, I added words to each arrow, cutting strips from laser-printed copies.

Finding Inspiration

The following pages show my personal process in making paper clay art. As you will see, my work begins with a sketch, which leads to a plan, which leads to my clay work. I rarely wing it. So much time goes into making the art, that I want to have a solid plan before I commit to working on a piece. That is not to say that I resolve every aspect before I begin. But I do try to have a strong sense of direction, placement of the clay and an artistic vision of the work I intend to make.

As long as I know what I'm going to make next, I am a happy camper. And so I am always thinking and daydreaming of my next project. I love coming up with a concept and imagining different ways to express it.

I am easily inspired and am always searching out my muses. Nature plays a huge role in my art because of its incredible beauty and sheer perfection. The work of other artists is always inspiring to me, especially the work of inventive, primitive, untrained and outsider artists. I love visiting museums, galleries, libraries, vintage shops, flea markets, cool boutiques, art supply stores, card shops and bookstores for ideas. And then there is the online access to infinite images of just about anything you want to see. Life is rich with inspiration.

Whatever it is, wherever it comes from, I try to capture it in my idea book. I carry a small sketchbook with me all the times so I can record and interpret my inspirations. I will do a little sketch and maybe write a few notes. Then when I need it, I have a notebook full of ideas to consider.

In the spring, I have only to walk down the street to find luscious flowers in bloom. Nature provides the best material to work from. But in the dead of winter, when I need to know what a poppy looks like, I am grateful for all the reference material at my fingertips. Whether from books, magazines, Internet searches or my own photographs, I can always find what I need within minutes. And if I need a figure in a certain pose, I can set up my camera and be my own model. Technology has certainly simplified the process of gathering good reference material.

I shoot a lot of photographs to use as references for my work but also find a lot of imagery by searching the Internet.

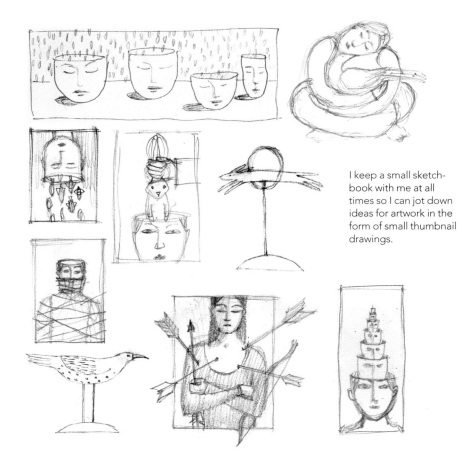

I keep a small sketchbook with me at all times so I can jot down ideas for artwork in the form of small thumbnail drawings.

 # My Basic Process

Taking an idea from concept to reality is a fun process. Perhaps my training as a graphic designer and illustrator has influenced my process because I have been doing it the same way for as long as I can remember. Every piece I make with paper clay begins the same way. First I do a small sketch, then draw it at the actual size, make an ink pattern on tracing paper, transfer the basic shapes to my board and trace over my design onto the clay. Then I cut the clay, apply it to the board and begin sculpting.

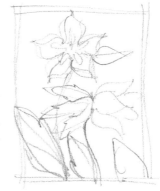

1 Sketch a small thumbnail.

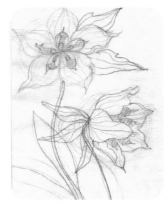

2 Draw a rough sketch of the thumbnail at full size.

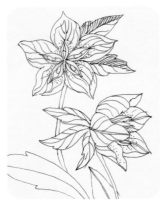

3 Ink the pattern on tracing paper.

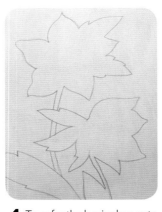

4 Transfer the basic shapes to a board.

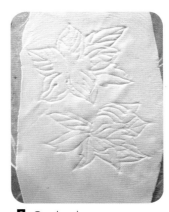

5 Cut the clay.

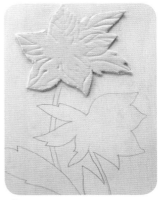

6 Apply the clay.

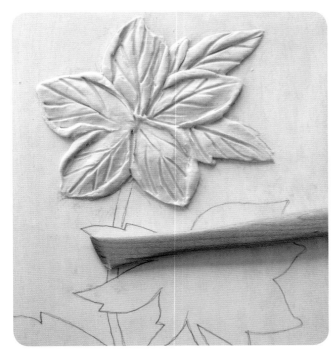

7 Sculpt the clay.

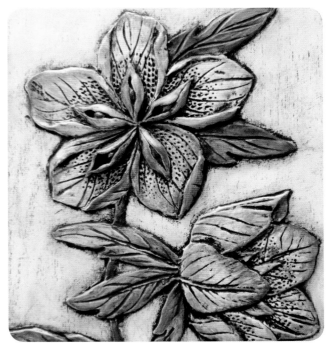

8 Finished piece.

Developing Your Ideas

When making a serious work using paper clay, I like to have a solid design plan. While I enjoy being spontaneous in my art making, I find working with clay requires more of a pragmatic approach. Here is the method I use in my basic process as illustrated on page 41:

Sketch the Thumbnail

I start every art piece with a thumbnail sketch. This is where I resolve the design and layout of my image before going any further. I do a quick pencil sketch of my idea, using just enough detail to give the essence of my thoughts. Then maybe I will do a few other sketches using the same elements while deciding upon my composition. I never draw directly on my substrate because I want to preserve its surface while I work out my ideas on paper.

Once I have my thumbnail composed, I sketch out a rough design in pencil to the actual size on paper. Sometimes I will digitally enlarge my thumbnail with my scanner to help me get started and keep my proportions the same. This is where I work to get my shapes accurate and refine my composition. Rather than doing a lot of erasing, I layer tracing paper over my sketch and keep refining my image until I have a drawing that I like. Sometimes this will take several layers.

Ink the Pattern

Once my design is sketched out in pencil, I get a fresh piece of tracing paper and cut it to the size of my substrate. I place it over my pencil sketch and trace over my drawing with a black permanent marker. While I trace, I make small corrections, refine shapes and develop details. Sometimes I add another clean sheet of tracing paper over this and continue to refine my image. It is far easier to make changes now than it is when the clay is on the board. Plus, the more you draw, the more you will train your hand, eye and imagination to work together.

Transfer the Design to a Board

Now that I have my pattern in ink on sturdy tracing paper, I transfer the basic shapes of my design to my prepared board, which has been painted with gesso and sanded smooth. I tape the pattern to the top of the board and slide a sheet of carbon paper beneath it. Having my pattern in ink helps me to see the design when the carbon paper is placed under it. I trace over the basic shapes so I know where to place the clay. Details are not necessary and would be covered by the clay.

Transfer the Design to the Clay

After rolling out a slab of clay to the desired thickness, about $^1/_{16}$" to $^1/_8$" (2mm to 3mm), I lift the clay to be sure it is not stuck to the plastic sheeting and place it on a clean area of the plastic. Then I place my ink pattern over the clay and trace over my main subject with a ballpoint pen, being sure to go over every detail. The idea is to press hard enough to impress the image into the clay without poking through the paper. This is why using a sturdy tracing paper is essential. I begin with my main subject first, then when I have sculpted it to my satisfaction, I go back and trace over other elements, adding and sculpting them as I go.

Dry-cleaning bags are very thin and can be used over the clay, under the tracing paper to keep the moist clay from dampening your pattern. Just be sure to press firmly while tracing your design onto the clay so that your impression is readable.

I can decide what mood or style I want for my image by drawing thumbnails of the possibilities such as this variety of flowers.

 # Layout and Composition

Though I have been a designer for many years, my approach to composing my artwork is not academic. There are books on the subject of composition if you feel you need a better understanding of it. For me, it either looks right or it doesn't. I think we all have an innate sense of balance that can be applied to our art. Here are a few things I try to keep in mind when planning my pieces:

Don't let your subject float in space. Rather than making a vignette, connect your subject to the sides so it is part of the picture plane. This grounds the image and gives it a sense of place. It can be as simple as a line to indicate the horizon or a tabletop.

Pick the star of the show. Pick one or two main items and give them emphasis by making them larger than all the other elements. Some things should stand out while others recede. If all elements are close to the same size, there will be no focal point.

Stay away from the corners. When using a rectangular or square surface, imagine a large oval or circle that nearly touches the edges and keep the important parts of your image within it. Avoid putting anything important in the corners or it will pull the eye to it and disrupt the flow of the composition.

Look at it in the mirror. One sure test when evaluating a composition is to view the reversed image in a mirror. It's like looking at someone else's design, which is always easier to critique than your own. Your natural sense of balance will help you see if you need to adjust anything.

Style and Mood

There are many ways to draw anything. For example, it can be realistic, stylized, abstract, decorative, whimsical or modern. I like to make art that fits the mood of the story I am trying to tell. But sometimes I tell a sad story using a lighthearted style because I like the juxtaposition. Think about how best to tell your story. Allow yourself to be experimental in this sketching and planning stage.

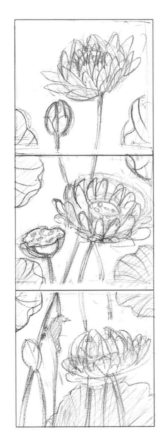

My thumbnails are the basis for more detailed drawings. These tiny sketches help me work out my idea and design as well as the proportions and composition before launching into the actual drawing.

Here is the more refined drawing that resulted from the rough thumbnail sketch to the left.

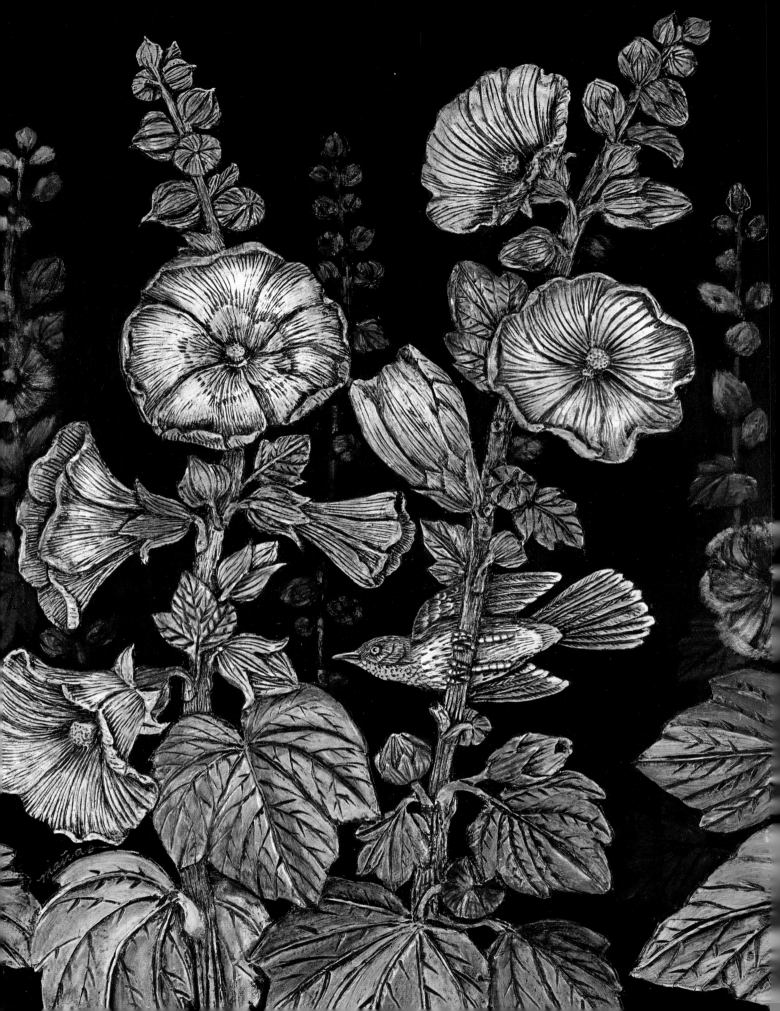

CLAY work PROJECTS 2

The five clay work projects shown in this section use a variety of techniques learned in section 1. Each project gets progressively more complex and challenging. If you complete the projects in order, you will become more adept at sculpting and adding detail work as you move forward. I encourage you to make them your own by adding your artistic style and proportion to each clay project and when using the finishing techniques you will learn in section 3. See page 140 for information about sharing your completed projects online.

HOLLYHOCKS
Paper clay and acrylic
on panel
18" × 14" (46cm × 36cm)

Leafing Out

Leaves are simple shapes that are familiar to us all. One has only to step outside to find endless varieties for inspiration. This first project goes rather quickly and has lots of ways for you to hone your skills before launching into more complex images.

 The pattern for this project can be found on page 51. Simply copy it onto tracing paper using a fine point marker. You can also make your own leaf patterns.

MATERIALS

- Clay Work Toolkit (pg 11)
- Design Toolkit (pg 11)
- 5" × 7" (13cm × 18cm) substrate prepped with gesso

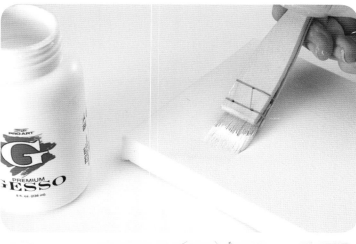

1 Prepare the Substrate

Though canvases come already coated with gesso, they sometimes feel slick and so I prefer to coat them with my own gesso for a more porous finish.

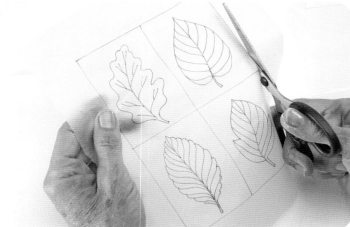

2 Create Your Pattern

Using a fine point marker, sketch the template on page 51 onto tracing paper trimmed to fit your 5" × 7" (13cm × 18cm) canvas. Feel free to draw your own leaves instead of using the template.

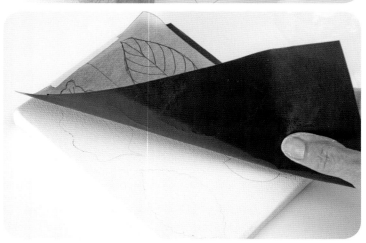

3 Transfer the Design to Canvas

Tape your pattern to the top of your canvas and transfer the basic shapes of your design to the surface using carbon or transfer paper. This shows where your clay pieces will be placed.

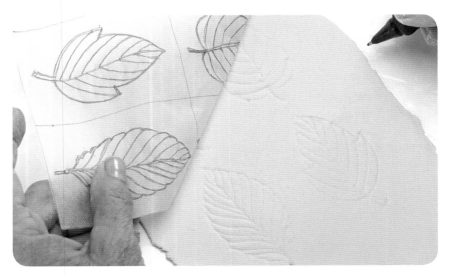

4. Transfer the Design to Clay

Roll a 1/16" to 1/8" (2mm to 3mm) thick slab of clay large enough to accommodate all the leaf images. Always lift the clay after rolling to be sure it is not welded to the plastic. With a ballpoint pen, trace over the individual leaf shapes, including details, to imprint the pattern into the clay. Check your impressions while transferring the images to the clay by lifting your tracing paper pattern enough to be sure you are making an impression you can see well. Ignore the stems for now.

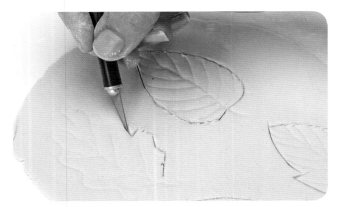

5. Cut the Clay

With a sharp and clean craft knife, cut the clay around the edges of each leaf. Use a scoot-scoot-scoot method of cutting rather than trying to cut in long strokes. You can dip your knife in water to help it glide better.

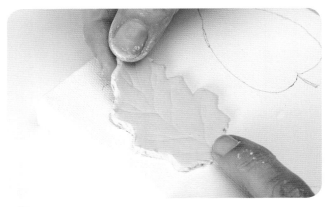

6. Place the Clay

Smear water onto your canvas where the carbon image indicates, and put your first clay leaf in place. Press it gently so that it adheres to the canvas without having air bubbles trapped underneath. Cover your clay remnants with sheeting.

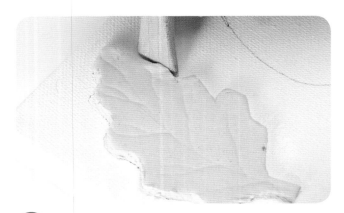

7. Shape and Smooth Edges

Using a tiny bit of water on your tool (or finger), smooth the rough-cut edges of the leaf because they dry out quickly.

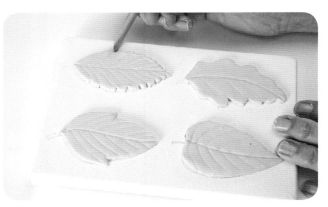

8. Add the Rest of the Leaves

Add the rest of the leaves in the same manner, being sure to smooth and shape the edges. Or you can proceed with sculpting the first leaf and add the others later.

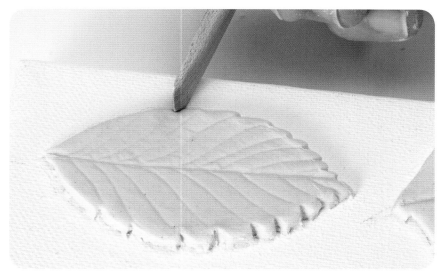

9 Nudge the Clay

Nudge the clay to create scalloped edges. It is easier to use your clay tool and nudge the edge of the clay to make scallops than it is to cut them when they are this small.

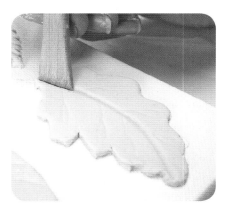 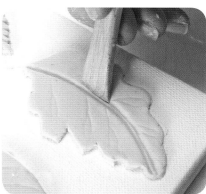

10 Sculpt the Central Vein

Using your clay tool, stroke deeply along the center of each leaf to make a central vein. To make a raised vein, stroke alongside the first stroke, leaving a narrow space between them.

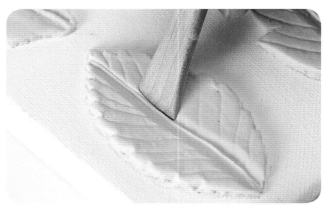 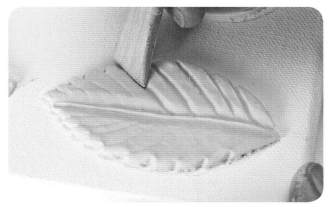

11 Sculpt Each Leaf

Press along the sides of each central vein to depress the clay on one or both sides of it. This gives a more sculptural look to the leaves.

12 Stroke the Individual Veins

Using your clay tool, stroke each vein on each leaf. Exaggerate the depth of each vein so your impressions are nice and deep. When you are satisfied with the veins, smooth the surfaces of your leaves with your clay tool before you begin making detail marks.

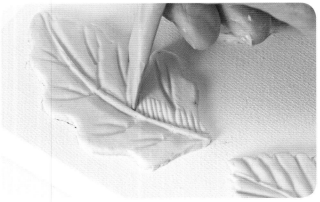 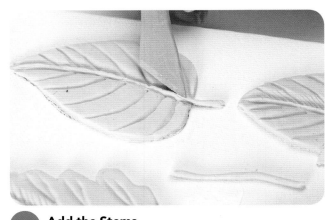

13 **Add Shading Detail**
On two of the leaves (upper left and lower right), add hatch marks along the central vein for shading. Once painted, these marks will hold a dark color and create a shadow effect.

14 **Add the Stems**
Roll a thin little snake from your clay for each stem. Smear water at the base of each leaf and attach a tiny stem by pressing it to the canvas using your clay tool. Reshape and blend each stem into the central veins.

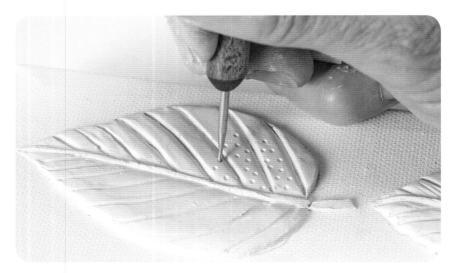

15 **Dry the Leaves and Add More Detail**
When you have all your leaves the way you want them, allow the clay to dry until it is white and hard. See page 34 for tips on how to speed drying times. Once dry, you can use a ball stylus tool or toothpick and press dots into two of the leaves. This adds an interesting effect when painted.

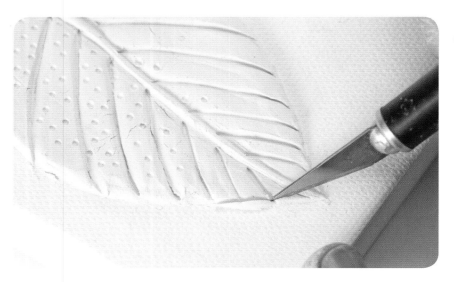

16 **Clean and Trim**
Using a craft knife, trim the points and edges of your leaves and stems as needed, taking care not to cut through your canvas. See the complete dry clay work on page 46.

Turn to page 92 for instruction on painting and adding finishing details to the piece.

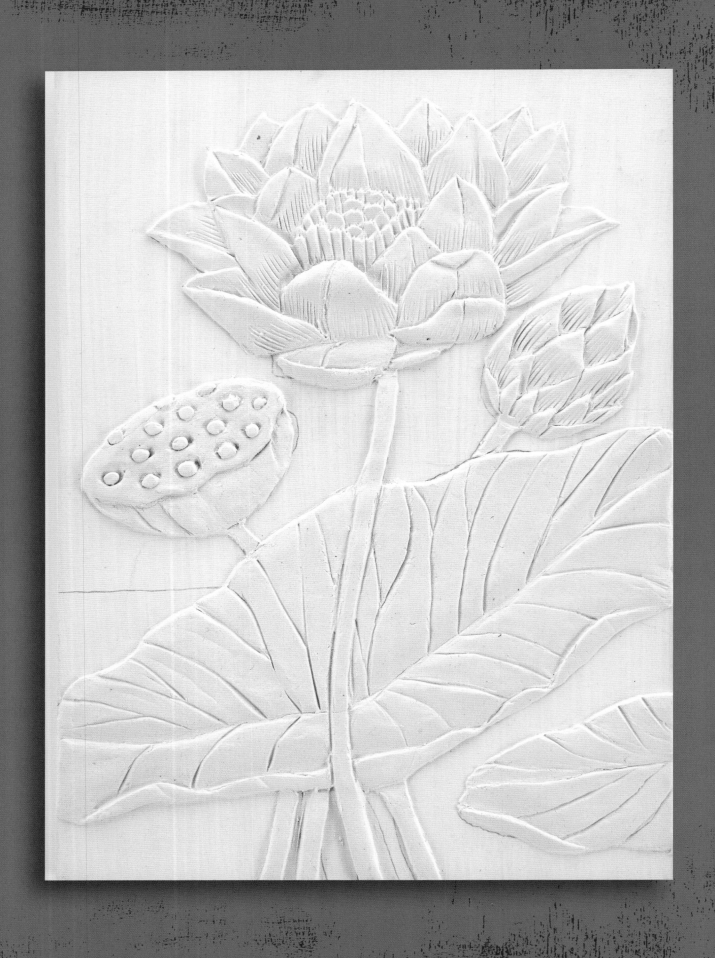

Lotus Lilies

Flowers are often the subject of art yet can present a real challenge to capture. To make a realistic bas-relief representation of a flower, it is important to understand the structure of the subject. The inspiration for this design is a vintage botanical illustration that did a beautiful job of depicting the structure of a complex flower, while providing layers of other elements such as buds, pods and leaves.

The pattern for this project can be found on page 57. Simply copy it onto tracing paper using a fine point marker.

MATERIALS

❋ Clay Work Toolkit (pg 11)

❋ Design Toolkit (pg 11)

❋ 5" × 7" (13cm × 18cm) substrate prepped with gesso

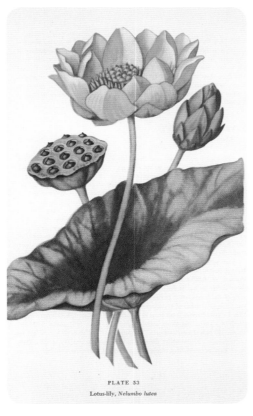

PLATE 53
Lotus-lily, *Nelumbo lutea*

1 Study Your Reference

My inspirational image is from *The MacMillan Wild Flower Book* (1954) illustrated by Edith Farrington Johnston. It helps to refer back to it while you are sculpting.

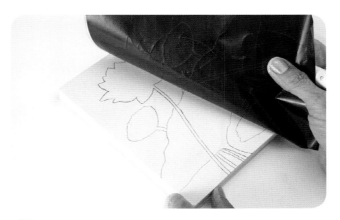

2 Sketch and Transfer the Design

Using a fine point marker, sketch the template on page 57 onto tracing paper trimmed to fit your 5" × 7" (13cm × 18cm) board. Tape your pattern to the top of your panel and transfer the basic shapes of the design to the surface using carbon or transfer paper. I am working on cradled wood panel for this demonstration.

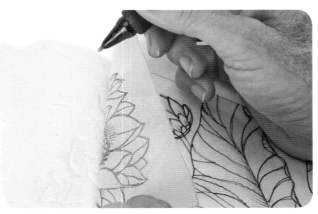

3 Transfer the Design to Clay

Roll a 1/16" (2mm) thick slab of clay large enough to accommodate the entire image. Transfer the large flower with its details onto the clay using a ballpoint pen. Check to be sure your marks are deep enough to see in the clay.

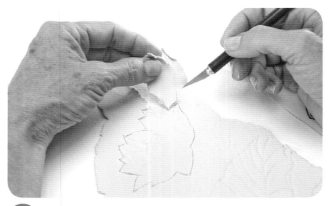

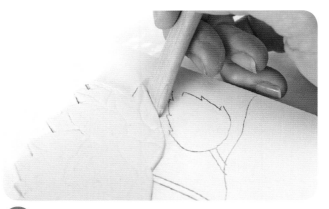

4 Cut the Clay

Using a sharp and clean craft knife, cut out the flower. Turn the clay as needed so you have the best angle for cutting. Dip your blade in water to help it glide through the clay.

5 Place and Smooth the Clay

Smear water where the flower will go and place the clay cutout on the spot, pressing gently to be sure it adheres. Press out any air bubbles trapped under the clay. Smooth the outer edges with a tiny bit of water and your clay tool. Cover the rest of your clay slab with plastic.

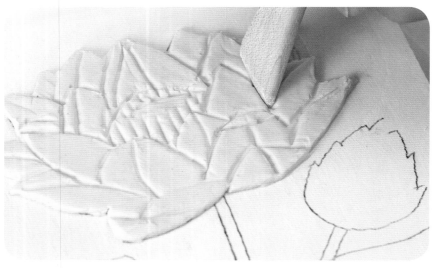

6 Define the Lines and Forms

With your clay tool, stroke or press all of your tracing marks deeply to define each petal as well as the center of the flower.

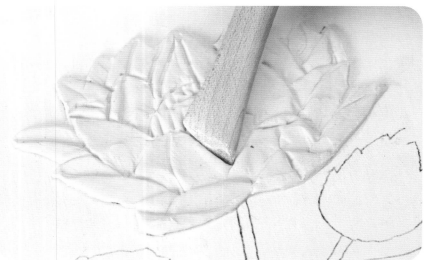

7 Begin Sculpting

Once the lines of the flower have been defined, begin sculpting by giving shape to each petal. Start with the outer petals and work toward the center. Wherever one petal goes behind another, press the clay inward.

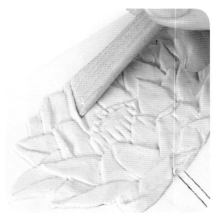
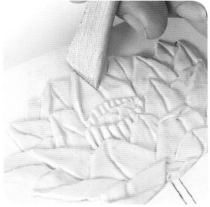

8 **Create the Illusion of Depth**
Wherever a petal folds over itself, press the underside down. Treat the center of the flower in the same way, pressing down on the parts that are behind, making what is in front appear raised.

Often, when sculpting, you might push on one thing that undoes another. Be patient and persevere. This stage of the work is a series of shaping and smoothing adjustments.

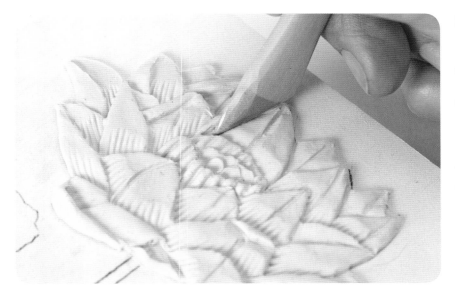

9 **Add Vein Details to the Petals**
When your sculpting is finished, you can stroke each petal with a center vein that follows the contour of the petal. This will help show the curves of the petals. Then add hatch marks for shading beginning from the base of each petal and following its curve. Sand both sides of your wooden clay tool to sharpen the edge for making finer detail strokes.

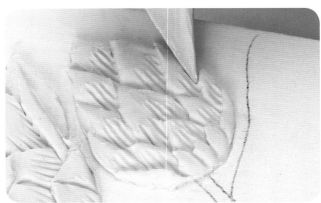

10 **Place and Sculpt the Bud**
Repeat the previous steps for the bud, treating the petals the same as those of the flower, pressing down on places where one petal goes behind another. Then you can add hatch marks for shading when you finish sculpting and smoothing the bud.

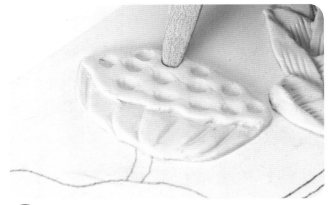

11 **Place and Sculpt the Pod**
The simple shape of the pod is accentuated by pressing its sides down to make the top appear a bit raised. Stroke lines that follow the curve of the sides to help define the shape. Using the curved part of your clay tool, add the divot pattern to the top where the seeds will be placed.

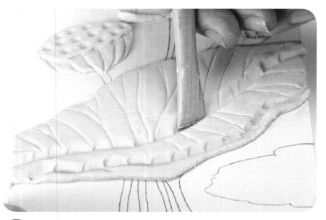

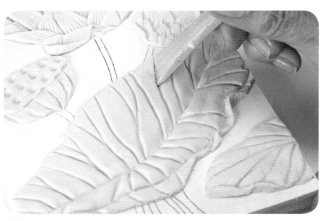

12 Place and Sculpt the Leaves

The leaves of a lotus lily are an inverted cone shape where they connect to the stem. To create the illusion of depth in the center of the leaf, press down along the top of the line across the middle of the leaf, dividing it into foreground and background.

13 Smooth Your Edges

Using your clay tool, smooth along the edge that you pushed back. Sometimes you will smooth out your tracing lines and will need to refer to your pattern. Stroke all the veins as they follow the contour of the leaf down into the center.

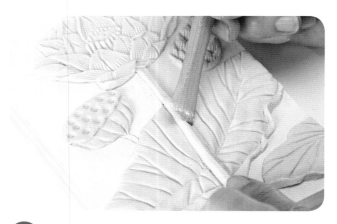

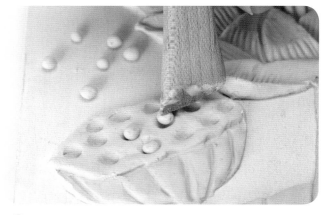

14 Add the Stems

Cut strips of clay about ¼" (6mm) wide and add all the stems, being sure to apply water before placing each one. Press back on both sides of the flower stem so that it appears to be raised.

15 Add Seeds to the Pod

Roll tiny bits of clay into balls to make seeds to place in the divots in the top of the pod. If they do not adhere well, use a bit of white glue to hold them in place once they have dried.

16 Clean Up the Edges

Once everything is dry, you can trim the edges of petals and leaves as needed with a craft knife. Sand off any unwanted bits of clay and smooth the leaf tops and stems with fine-grain sandpaper. Your clay work is now ready for finishing. See the complete dry clay work on page 52.

Turn to page 98 for instruction on painting and adding finishing details to the piece.

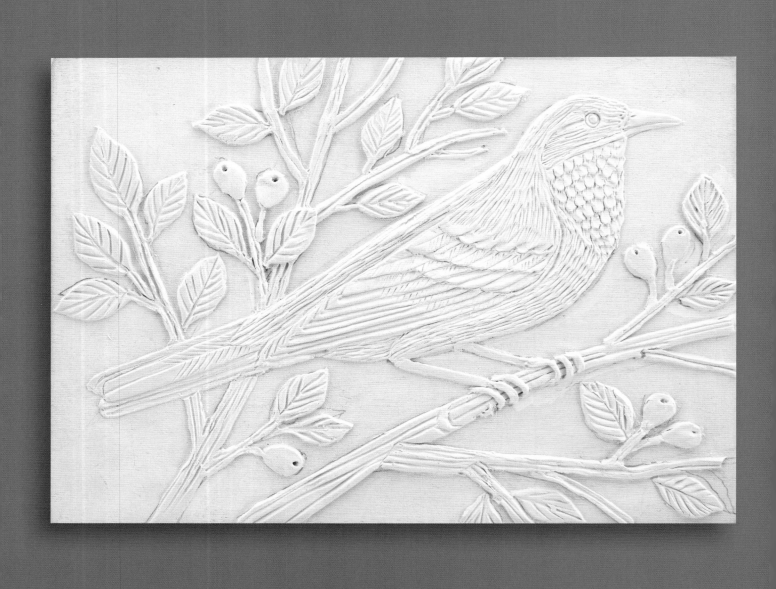

Friend of a Feather

Birds make great subjects for paper clay because they have simple shapes with lots of texture and detail. Plus branches, berries and leaves are simple shapes that add interest. It is best to sculpt the bird first and then add the branches and background later. You can wait to add the legs and feet until the branches are in place, textured and nearly dry. Each part can dry separately, making it easy to work on each part over time so you don't have to do it all at once.

The pattern for this project can be found on page 65. Simply copy it onto tracing paper using a fine point pen or marker.

MATERIALS

- Clay Work Toolkit (pg 11)
- Design Toolkit (pg 11)
- 5" × 7" (13cm × 18cm) substrate prepped with gesso
- ballpoint pen parts

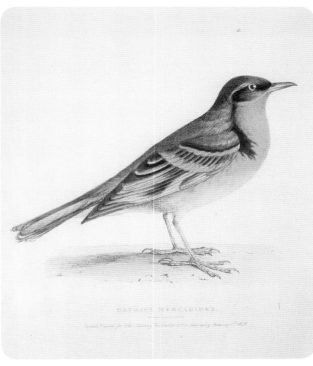

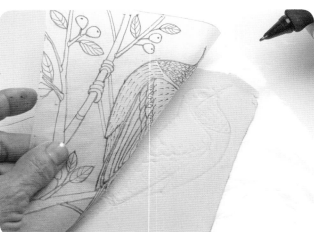

1 Study Your Reference

My inspiration for this project was a vintage bird illustration from *Zoology of the Northern Parts of British America, The Birds* (1831). Refer to it often as you sculpt.

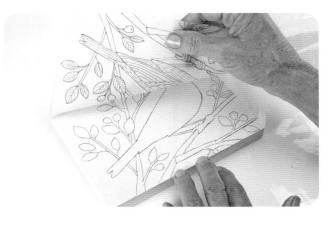

2 Sketch and Transfer the Design

Using a fine point marker, sketch the template on page 65 onto tracing paper trimmed to fit your 5" × 7" (13cm × 18cm) substrate. Tape your pattern to the top of your canvas and transfer the basic shapes of the design to the surface using carbon or transfer paper. No need for details. I am working on cradled wood panel for this demonstration.

3 Transfer the Design to Clay

Roll a 1/16" to 1/8" (2mm to 3mm) thick slab of clay large enough to cut the bird in one piece. Always lift the clay after rolling to be sure it is not welded to the plastic. With a ballpoint pen, transfer the pattern to the clay, beginning with the bird. Trace over all the lines and check if your marks are deep enough to see.

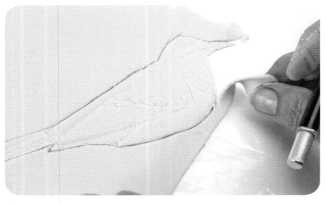

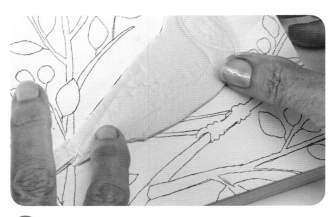

4 **Cut the Clay**
With a sharp and clean craft knife, cut around the outside of the bird remembering it is easier to scoot your knife in small strokes than it is to try making long strokes.

5 **Place and Smooth the Clay**
Smear water on your canvas, place the cutout of the bird on it and gently press it into place. Watch for air bubbles trapped under the clay. Smooth all the edges with your tool and a dab of water.

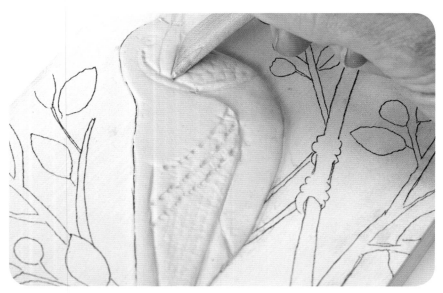

6 **Begin Sculpting the Details**
Using your clay tool, stroke over your imprinted lines to deepen them and sculpt the basic shapes of your bird including the beak, the neck, the breast, the top of the wing, the wing feathers and the tail feathers.

7 **Raise the Wing**
Make the wing look like it is raised from the body by pushing down along the bottom edge with the side of your tool. Then smooth it out. The clay may need to dry a bit before adding detail, so spend this time reinforcing all your lines and smoothing the surfaces of the bird.

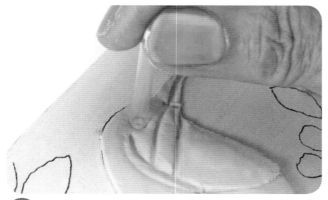
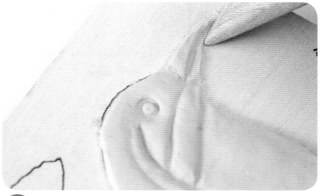

8 **Imprint the Eye**

The face of the bird is an important focal point and deserves careful attention. As the clay begins to firm up, it is time to make the eye. Use a small tube such as the inside of a pen for imprinting the eye. A larger tube can imprint a second circle to add more realism.

9 **Refine the Beak**

Shape the beak carefully, adding a line for the mouth and a tiny little nostril. You can trim it to perfection once it is completely dry.

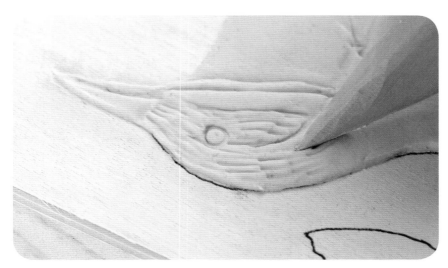

10 **Start the Feather Markings**

Beginning on the head next to the beak, stroke little lines toward the body just as feathers grow on a bird. Stroke around the eye carefully. You may need to re-imprint the eye with your tubes if needed.

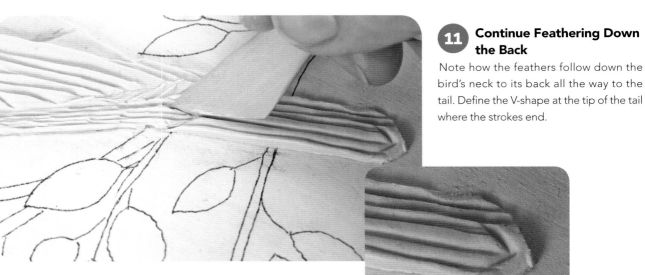

11 **Continue Feathering Down the Back**

Note how the feathers follow down the bird's neck to its back all the way to the tail. Define the V-shape at the tip of the tail where the strokes end.

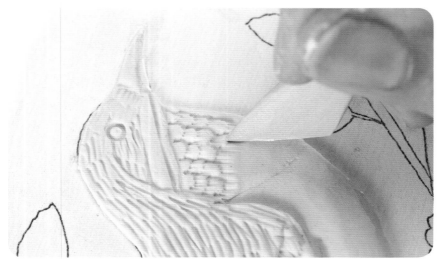

12 Create Scallops on the Breast

Using the point of your tool, sculpt little U shapes in rows to simulate breast feathers by tapping down the clay with little strokes. You can also use a small straw or tube for this. Start under the beak and work your way down the breast.

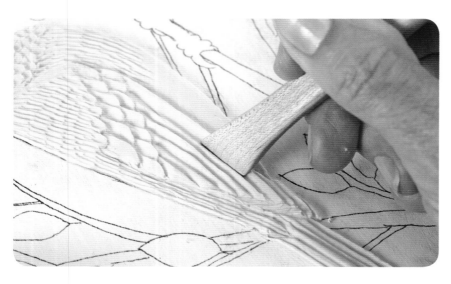

13 Form Some Longer Feathers

Sculpt two rows of longer scallops to complete the cap of the wing. Add dimension to the feathers by pressing under each row of feathers and along each wing feather to stair-step them beginning at the bottom of the wing.

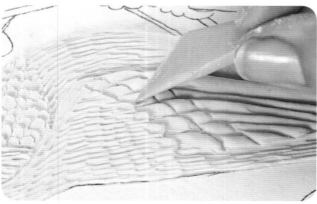

14 Use the Best Tool for the Job

A sharpened tool works best for crisp lines and fine details while a more blunt tool is best for shaping, smoothing and flattening. You can create a blunt tool by sanding the point down on a commercial tool.

 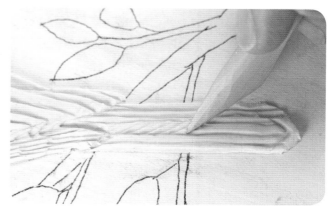

15 Sculpt the Wing and Tail Feathers

Add some detail strokes to indicate feathers on the tail and wing. Start with the top tail feather, stroke down the center of it and then add chevron strokes to either side. Continue adding a few chevron strokes to the rest of the tail feathers. Create the same effect at the tops of the wing feathers.

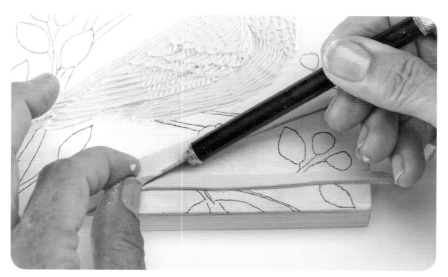

16 Add the Branches

Using your leftover slab, cut strips of clay to lay down as branches. No need to trace this as branches are basic simple shapes. Form each branch, making sure to add texture to it with strokes. Branches are wider at their base and get narrower as they go out.

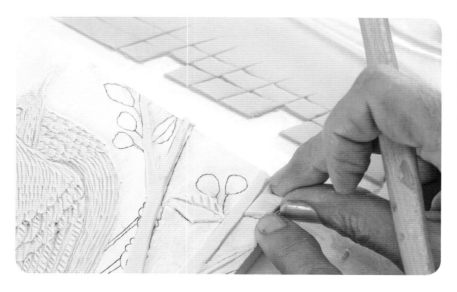

17 Add the Leaves

Cut diamond shapes that will become leaves from your slab, then place and sculpt each one in place. For detailing, start with a center stroke and then add the chevron-shaped veins.

18 **Add the Berries**

Roll tiny balls of clay to place and sculpt on your board. Note that each berry is more of an oval than a circle. Place a small dot at the top of each berry with a toothpick or similar tool.

19 **Add the Bird's Legs**

Attach your bird to the branch by cutting small strips of clay to form into legs. One end goes to the bird, the other end to the branch. Smooth the sides of each leg.

20 **Add the Feet**

Ideally your branch is firm enough to add the feet over it. Roll some clay into a tiny snake the width of a toothpick. Cut it into ½" (13mm) strips and place each one onto the branch and form a C shape to make each toe. It is important that you smear water underneath before placing and pressing the tiny feet. Use your tool to nudge the toes into shape and press each one down gently to help it adhere to the branch.

Tiny things can be difficult to adhere. Sometimes you will need to cut away the excess clay created when pressing with your tool and reshape as needed.

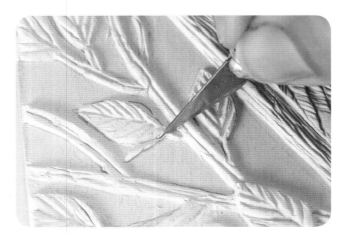

21 **Clean Up and Trim the Leaves**

Once your artwork is dry, you can trim things as needed like the points of the leaves, the bird's beak, etc. See the complete dry clay work on page 58.

Turn to page 104 for instruction on painting and adding finishing details to the piece.

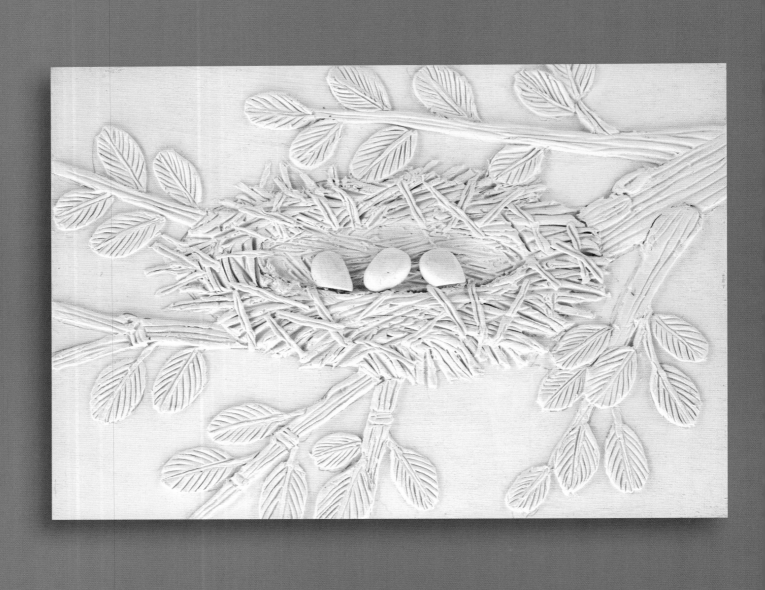

Nesting

A bird's nest is one of nature's architectural wonders. Mimicking the random construction and irregular shapes of a twig and grass structure with paper clay can be fun. The same techniques used to make the nest can be applied to other textured surfaces like grassy foregrounds. Once again, understanding the structure of the nest is important as you create a bowl for the eggs. And the eggs, which are formed, partially dried and then cut in half, are added to the dried clay nest with white glue. The most challenging part of this project is rolling tiny bits of clay and getting them to stick to your work. Just be sure to always apply a bit of water on the surface first.

The pattern for this project can be found on page 71. Simply copy it onto tracing paper using a fine point pen or marker.

MATERIALS

❋ Clay Work Toolkit (pg 11)

❋ Design Toolkit (pg 11)

❋ 5" × 7" (13cm × 18cm) substrate prepped with gesso

❋ white craft glue

❋ fine-grain sandpaper

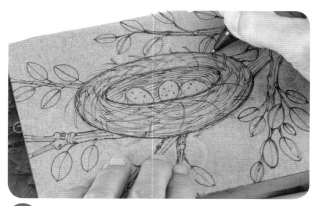
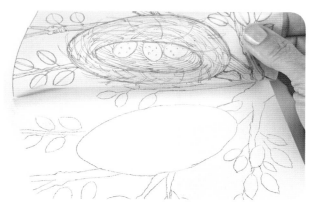

1 **Transfer the Design to Your Substrate**
Using a fine point marker, sketch the template on page 71 onto tracing paper trimmed to fit your 5" × 7" (13cm × 18cm) canvas. Tape your pattern to the top of your canvas and transfer the basic shapes of the design to the surface using carbon or transfer paper. No need for details. I am working on cradled wood panel for this demonstration.

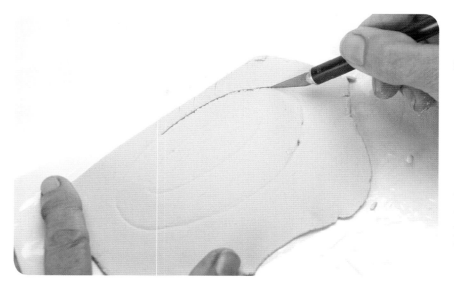

2 **Transfer and Cut Out the Nest Design**
Roll a 1/16" (2mm) thick slab of clay large enough to accommodate the nest. Lay your tracing paper on top and draw over the inner and outer ovals. Because you will be sculpting a freeform design, there is no need to include detail. Using a sharp and clean craft knife, cut out the nest. Dip your blade in water to help it glide through the clay.

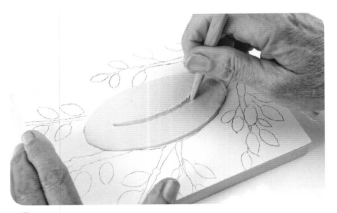

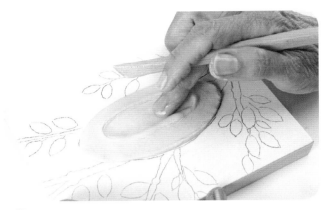

3 **Place and Form the Nest**
Smear water where the nest will go and carefully place the clay cutout on the spot, pressing gently to be sure it adheres. Press out any air bubbles trapped under the clay. Smooth the outside edge with your clay tool and a bit of water, then stroke the inside oval line with your clay tool as deeply as possible. This defines the inside of the nest bowl.

4 **Form the Inside of the Nest**
Use your fingers to press the inside of the inner oval flat, forming a bowl shape. If your clay is thick, move excess clay toward the bottom of the oval, adding to the front part of the nest.

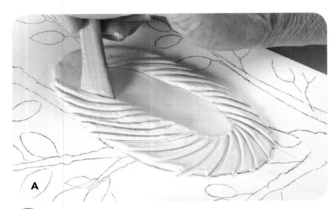
A

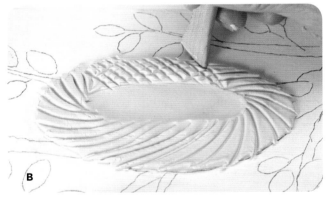
B

5 **Sculpt the Outer Nest Texture**
Create a textured base for the nest. Using your clay tool, stroke deep diagonal lines across the outer oval, working around the whole area (A). Next, stroke in the opposite direction, covering the entire large oval with a crisscross texture (B).

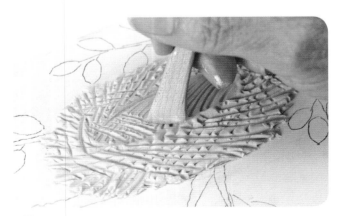

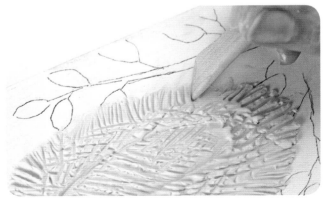

6 **Sculpt the Inside the Nest**
Make diagonal crisscross strokes on the inside of the nest bowl to add texture.

7 **Texture the Outer Edges of the Nest**
Use your clay tool to cut lines radiating out along the edge of the nest to give it a more free form texture.

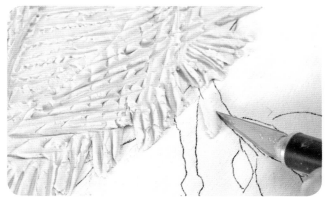

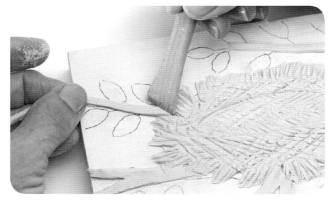

8 Place the Clay

To make the outer edge of the nest look as though it is made of sticks and straw, cut away some of the clay with a craft knife, leaving sticklike shapes along the edge.

9 Add the Branches

Roll another slab of clay large enough to cut out all of the remaining items (leaves, eggs, raised sticks). You can trace the branches and cut them out or simply cut strips of clay that are the approximate width of each branch. Place and form all of the main branches being sure to smear water on your substrate first, then smooth all the edges.

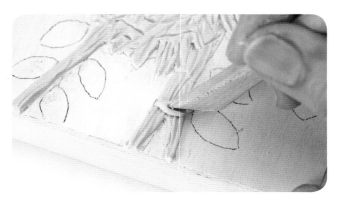

10 Add Texture to the Branches

Make the branches look more like wood by stroking them with your clay tool. Add little blobs of clay to simulate knots and gnarls, giving your branches more character.

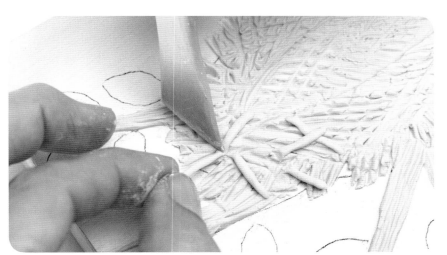

11 Add Worm Shapes to the Nest

To make the nest look more like it was constructed with individual sticks and straw, add tiny strips of clay to the top of it. Roll long and thin worm shapes of clay with your fingers. Cut the worms into ½" (13mm) lengths and place them around the outer oval of the nest, applying a bit of water first. Take care to place them in the opposite direction from whatever is beneath them.

12 Sculpt the Worm Shapes

To integrate the worm shapes into your nest, stroke each one down the middle using a sharpened clay tool. This makes the added pieces integrate with the original texturing.

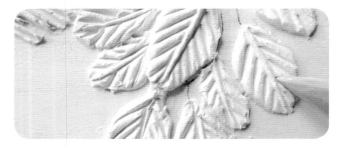

13 **Roll and Cut Leaves as You Work**
When adding lots of leaves to your work, simply cut a bunch of diamond shapes from your excess rolled clay. Then place, form and trim each leaf on your substrate. Add texture to each leaf as you go.

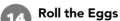

14 **Roll the Eggs**
Rather than cutting oval shapes for the eggs, it is more realistic to form egg shapes and cut them in half so they can be glued into the nest. Take a tiny wad of clay into the palm of your hand and use the other palm to roll a perfect ball. Then gently roll into an egg shape with your fingers.

15 **Cut the Semidry Eggs in Half**
Allow your eggs to dry until the outside feels hard, but the inside is still moist. Use a sharp craft knife to cut each egg in half, using a sawing motion so as not to apply too much pressure to flatten the egg. This helps to hold the form, but you may need to reshape each half.

16 **Trim and Sand the Eggs**
When the egg halves are dry, trim and sand them as needed. In this example, the ends of two eggs were cut away with a craft knife to make them look like they are down inside the nest. You can also sand the eggs a bit to make them appear more smooth if needed.

17 **Glue the Eggs in Place**
When everything is dry, adhere the eggs to the nest using white glue. Now is the time to add any other little details that might make everything look more natural like a few more bits of straw coming out over the branches. Once dry, your piece is ready for finishing. See the completed dry clay work for this project on page 66.

Turn to page 112 for instruction on painting and adding finishing details to the piece.

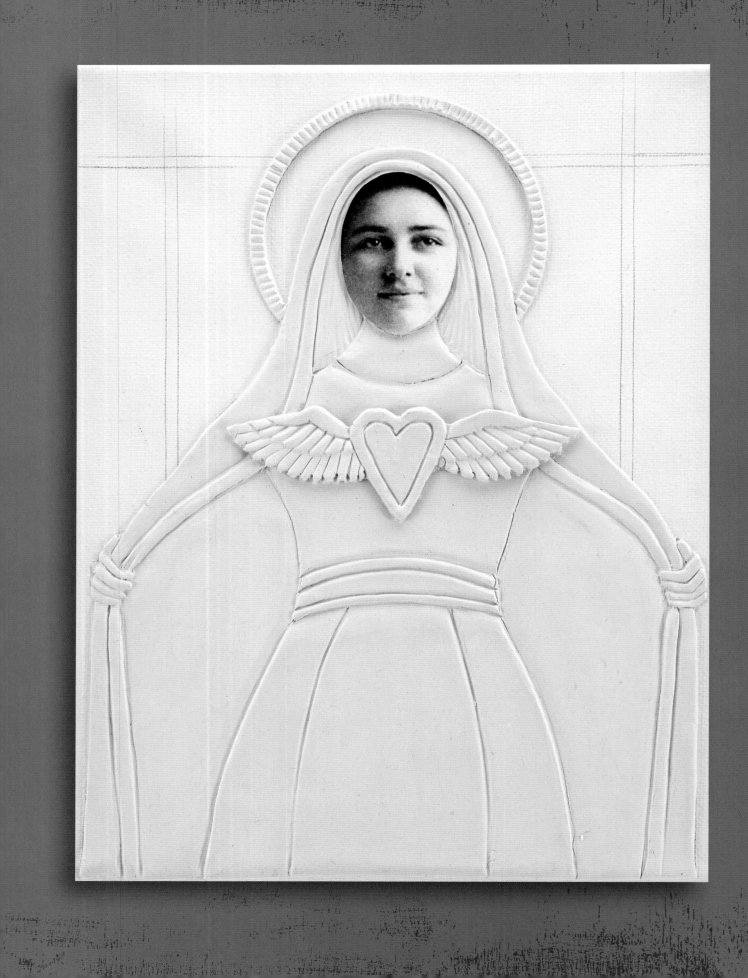

Set Your Soul Free

Make your own saints to help remind you of your dreams and aspirations. Choose a theme and then create the saint to embody it. Enjoy the playfulness of designing their costumes and embellishments. This project combines collage work with paper clay. You will add the face shown in the finishing section, or you can use a face image of your choosing. You will also apply collage papers in the finishing section. The winged heart and corner diamonds are created separately as appliqués, and are added after the collage papers have been applied.

The pattern and face for this project can be found on page 77. Copy the pattern onto tracing paper using a fine point marker. Make a laser copy of the face for best results; an inkjet image will likely smear.

MATERIALS

❋ Clay Work Toolkit (pg 11)

❋ Design Toolkit (pg 11)

❋ 8" × 10" (20cm × 25cm) substrate prepped with gesso

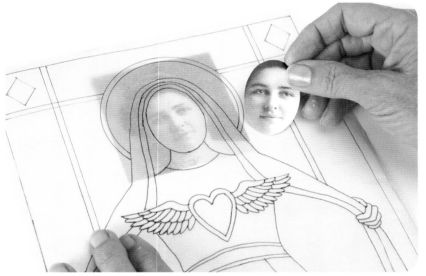

1 Sketch the Design

Using a pencil, sketch the template on page 77 onto tracing paper trimmed to fit your 8" × 10" (20cm × 25cm) canvas. Tape your pattern to the top of your canvas and transfer the basic shapes of the design to the surface using carbon or transfer paper. I am working on canvas for this demonstration. Make a laser copy of the face you choose and cut it out to fit the pattern. We will adhere this later in the finishing demonstration.

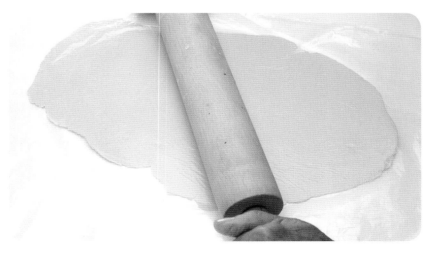

2 Roll the Clay

Roll a slab large enough to cut the entire figure in one piece. Lift the clay before proceeding. The halo and border lines will be added in a later step.

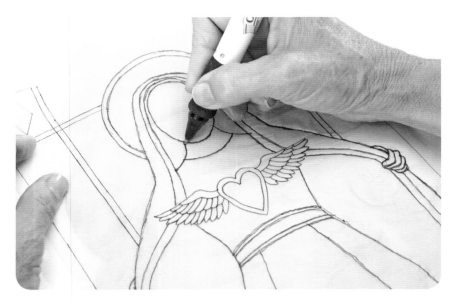

3 Transfer the Design
Transfer your pattern to the clay by tracing over all the lines being sure to check to see if you are making deep enough marks. Do not include the flying heart in this transfer because it will be done separately in a later step.

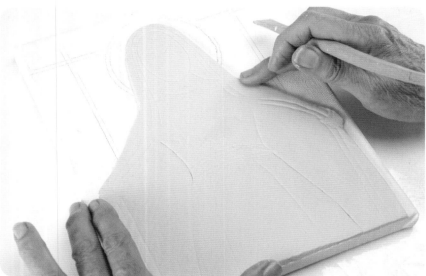

4 Place and Smooth the Clay
Using a sharp craft knife, cut around the outside of the figure. Dip your blade in water to help it glide through the clay. Smear water over the entire area where you will place the clay figure, then place it and press it gently from the center out to the edges to release any air bubbles trapped under the clay. Prick stubborn bubbles with your knife and smooth the areas with your tool. Once your clay is adhered to the surface, smooth the edges with your finger and a tiny bit of water.

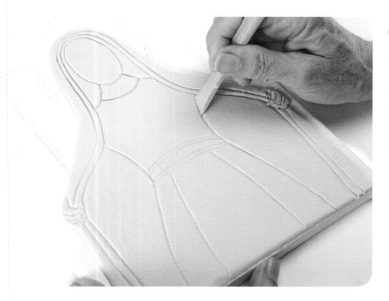

5 Place the Clay
Use your clay tool to stroke over all the lines on the figure. Starting with the head, smooth the surface where the face will be applied so it is flat. Next form the body, pressing back along the lines that should recede, like on the inside of the veil, along the sides of body and the hair area.

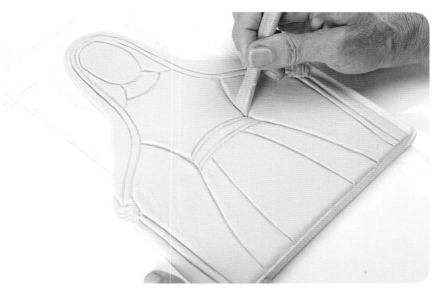

6 Deepen the Lines
Using your clay tool, deepen and smooth all the lines on the figure and on the trim of the veil. This will help when adding collage papers in the finishing section.

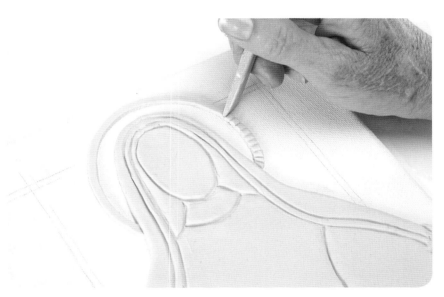

7 Make the Halo
Using your craft knife and a straightedge, cut a long strip of clay about 1/8" (3mm) wide from your slab scraps. Smear water on the outline of the halo and adhere the clay strip into a circle as shown. Use your clay tool to nudge it into a perfect circle. Once placed, use your tool to emboss small indentations into the halo radiating out from the center.

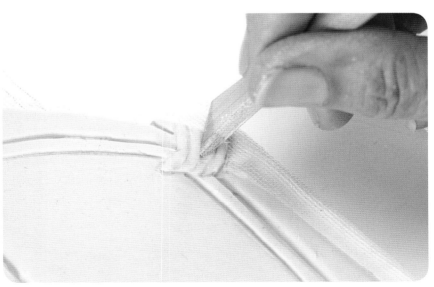

8 Form the Hands
Take special care to define the fingers and thumb of each hand. You can stair-step each set of fingers, pressing back along the little finger first, then moving to the next one and so on. A blunt tool works best for this.

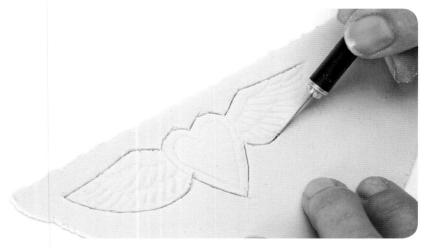

9 Transfer and Cut the Flying Heart

Once you have finished your clay work on the figure, transfer the flying heart outline to the clay slab, being sure to include all the details. Cut out the flying heart, outlining the basic shape of the wings without cutting around the tips of each feather.

10 Sculpt the Flying Heart

Place the cutout of the flying heart onto a piece of plastic and smooth the edges as you would an appliqué. (See page 32 for more on appliqué techniques.) Reshape as needed.

Stroke over all the lines on the heart and wings. Press down along the bottom row of feathers so the top row appears to be raised. Using your clay tool, shape each feather tip by pushing in where each line divides them.

11 Make the Corner Embellishments

With some of your remaining scraps, cut two matching diamond shapes and impress details into them with a circle tool, such as a small straw or tube from a ballpoint pen, and your clay tool. Here is the finished flying heart and corner embellishments. When the piece is completed, they will be secured in place with white glue. See the completed dry clay work for this project on page 72.

Turn to page 118 for instruction on painting and adding finishing details to the piece.

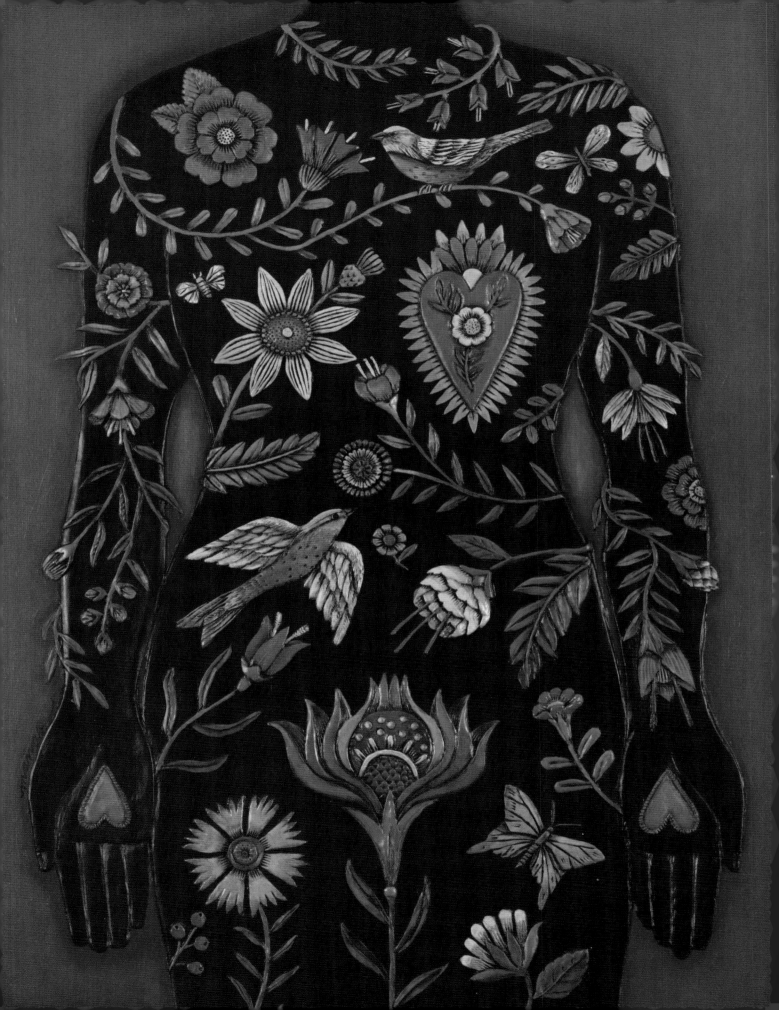

FINISHING
techniques
3

In this section you will learn all the ways to finish your clay work. The process includes sealing the clay, bringing out the details, painting and glazing your work, and adding collage materials if desired. You will learn ways to paint your clay work to help give it light and life by enhancing the form and details with color.

Once you have learned the basic finishing techniques, you can complete your clay work projects from section 2. Each project is painted a bit differently using opaque and transparent painting techniques. You can follow the painting instructions and use the color schemes shown, or you can do your own thing. The final project also includes some new collage papering techniques.

GARDEN OF EDEN
Paper clay and acrylic
on canvas
24" × 18" (61cm × 46cm)

Preparing Clay Work for Painting

Before painting your clay work with anything, you must always seal it properly with gesso and acrylic medium. Until it is sealed, it is vulnerable to moisture, breakage and staining. It is crucial that the layers of gesso and medium be individually dried and cured before being painted. Using a hair dryer will help the drying process and cure the mediums more quickly.

Here we are working with the clay practice projects from page 20 in section 1. Later in this section you will follow these same steps for preparing and painting all of the five paper clay projects.

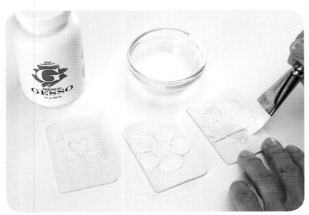

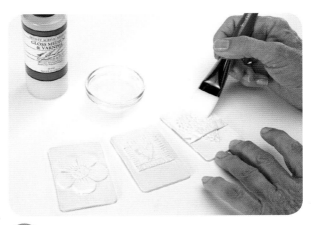

1 Gesso creates a consistent white ground for acrylic paint while sealing the clay from moisture. Use a very soft brush as a hard brush might scratch the surface of the clay work. Apply two thin coats of gesso, allowing the first coat to dry before adding the second. Swirl your brush to get the gesso into every nook and cranny. Hold it to the light so you can see where you are applying the wet gesso. Do not allow the gesso to pool anywhere, removing excess with your brush. If you notice any unwanted clay particles, scrape them away while they are moist from the gesso. They will be easy to remove using a clay or rubber-tipped wipe-out tool. Allow the gesso to dry and cure for 20 minutes. Be sure to wash your brushes and tools well afterward because gesso dries to a permanent finish.

2 When the gesso is completely dry, paint the entire surface with two thin coats of acrylic gloss medium, allowing each coat to dry completely. This forms a separation barrier that will keep the white gesso from staining, allow for more painting options and further protect your clay work. Apply each coat, swirling your brush to be sure everything is well coated. Do not allow the medium to pool anywhere, removing any excess with your brush. Let each layer of medium dry and cure completely.

Speed Drying Times

Though the gesso or medium might be dry, it still needs to cure to be permanent. Blasting it with a hair dryer will help to cure each layer more quickly, allowing you to start painting right away.

Thinning Gesso and Medium

If your gesso or medium is thick, you may need to thin it a bit with water. You don't want to plug up your detail work with thick gesso or medium. But take care not to thin it too much or it will weaken the finish.

Bringing Out the Detail

Now that you have prepared your practice projects with gesso and gloss medium and they have completely dried and cured, it's time to accentuate your clay work by applying a dark acrylic paint to the entire surface. It can feel a little disconcerting to be covering your pristine white clay work with dark paint, but this is the part of the process that brings out the depth and character of your clay work.

Black is the simplest color to use for this step because it makes for the most contrast and the easiest coverage. However, you can also use other dark colors such as deep blue, dark red, dark brown, etc. Or if you want a more subtle effect, you can use lighter midtone colors like sepia or gray. It is a matter of personal taste.

For this first exercise make a wash using Ivory Black paint and a bit of water on your palette. The consistency should be like a milkshake, smooth and not sticky like when the paint first comes out of the tube. Paint the entire surface of your clay work with the wash. Be sure to cover it completely. The paint should seep into all the crevices and be thin on the surface.

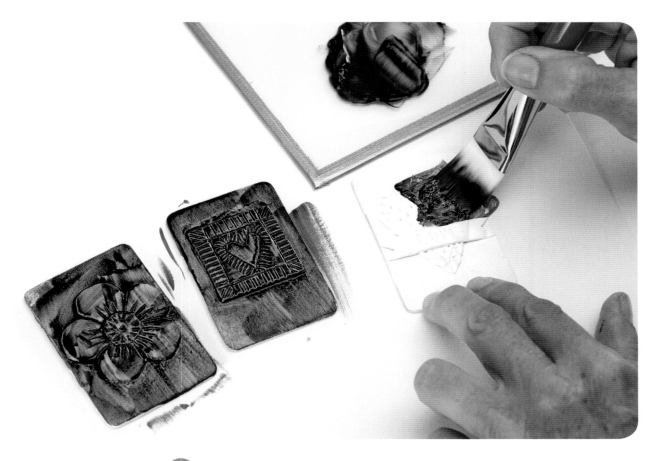

3 No need to paint the outer surface completely solid because you will be removing the paint from it or painting over it once it is dry. It is most important that the dark paint is in all the indentations and crevices, so check from every angle.

The Big Reveal

When the dark paint is dry, you will remove it from the surface of the clay work with rubbing alcohol. This will leave the surface white, while all the indentations are filled with the dark paint. This process enhances the clay work by creating contrast between the dark recesses and the light surface. It also adds character to the clay work that is somewhat reminiscent of printmaking. You will enjoy the element of surprise and discovery that comes with this part of the process. You will see the result of all your efforts at creating details.

Use care when working with rubbing alcohol because it is not only a solvent for the paint, but for the medium and gesso as well. Rub the surfaces gently while removing the paint so as not to disturb the barrier layers. Use rubber gloves when removing paint because the alcohol and paint combination can stain your hands since the pigment becomes separated from the emulsion. And who wants black fingernails? Be sure you always use rubbing alcohol in a well-ventilated space to avoid inhaling the fumes.

24-Hour Rule

Remove the dark paint within a day or it may become more difficult to remove. You want it to come off easily so as not to disturb the barrier layers with hard rubbing.

Watch Out for Staining

If the surface begins to turn gray and will not get any lighter, it is possible that you have rubbed through the barrier layers of medium and/or gesso and are now stain-ing the gesso and/or the clay. This can happen if you have thinned your medium too much with water, rubbed too hard, have not coated the clay enough with medium, or have not allowed enough time for the medium to dry and cure after applying it. You can repaint the affected area with thin coats of gesso and medium, taking care not to plug up your indentations. Then reapply the black wash and repeat the removal process more carefully. Aren't you glad to have pieces to practice on?

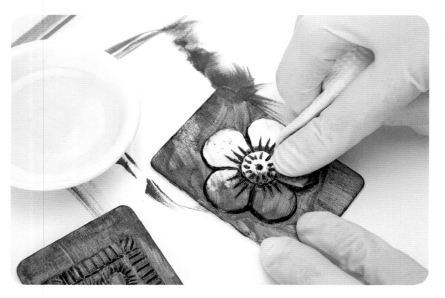

4 Allow the dark paint to dry completely. Pour some rubbing alcohol into a small container and dip a paper towel into it. Wipe off the black paint with gentle strokes. Rubbing too hard will remove the barrier layers and eat into the gesso.

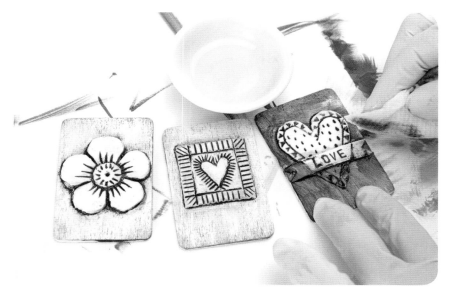

5 Turn your paper towel to keep a clean surface while removing the paint so you do not inadvertently smear more black paint back onto the clay surface. Continue to turn your towel, dip it into the alcohol and remove paint until you get the look you like. Always be careful not to rub too hard.

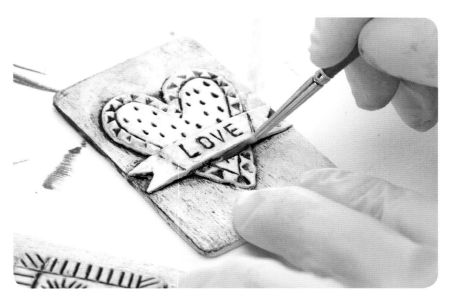

6 You can use a detail brush to go back and paint areas that need more emphasis, such as where shadows might fall or where paint was removed accidentally.

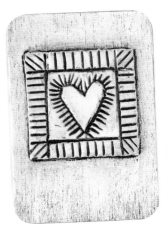 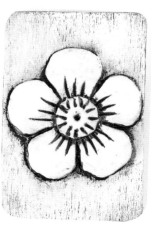 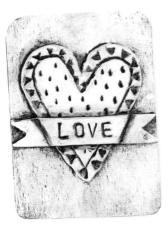

7 Once the dark paint has been removed, you can choose to leave your art black and white or add color. If leaving it without color, painting the background black it will make the clay work pop.

Color Mixing

Painting your clay work is a really fun process. You have already done all the work to create the form and details, and now you get to enhance them with color. You can use a variety of paints to do this such as watercolors or oils, but this book focuses on acrylics.

Mixing Colors

If you have not had a lot of experience mixing colors, it can sometimes be exasperating. Choosing the right colors to mix is critical because some paints are simply not good mixers. The following is a simplified method and explanation of color mixing. It is a good idea to test all your paints to see how they mix before applying them to your clay work.

Primary Colors

We were taught that the primary colors (red, blue and yellow) could be mixed together to create other colors. But realistically, if you do not use the right red, blue and yellow, you might not be happy with the results.

It is practical to use colors that mix well and create a wide variety of colors from as few tubes of paint as possible. These are not the only colors to use, but they are good staples to have on hand. Transparent, cool color paints tend to be better mixers than opaque, warm ones. Warm colors generally have some red mixed into them. Cool colors are more pure and you get the most variety from combining them. So for this version of primary colors, you will be using all cool transparent colors. For red, a magenta color like Quinacridone Rose (QR). For blue, a cyan color like Phthalocyanine Blue (PB). And a yellow like Azo Yellow (AY).

Mixing vs. Glazing

You can mix paint colors together, which will result in a solid color, or you can glaze one color over another to get a similar result, but a more interesting look. Glazing means to paint a thin layer of transparent paint over another color that has already dried. The bottom color can be seen through the top color because it is transparent. Your eye mixes them together visually.

Above is a dried swatch of yellow paint with a swipe of red paint over top. Next to it you can compare the top orange color block (created by mixing red and yellow together) with the glazed color block below (created by glazing red paint over dried yellow paint). The glazed version has more life to it, more interest to the eye. This is the advantage of glazing. You can use this technique to adjust colors, brighten them or add shading.

Tips for Working with Acrylic Paints

Here are some tips about using acrylics to paint your paper clay work:

- Acrylic paints dry quickly and are permanent, but need time to cure. Generally, if you allow the paint to cure for about 20 minutes, you can apply a second coat without disturbing the first. If you paint over the first coat too soon, the paint will act as a solvent for itself and the first layer of paint may come up. Use a hair dryer to speed up the process and cure the paint more quickly.
- Keep the paint on your palette moist with water. Acrylics dry quickly, so occasionally spraying your palette with a light mist of water will keep your paint usable longer, especially in dry or warm climates.
- If you need to take a break and have wet paint on your palette, spray it a couple times with water and then cover it with a plastic container turned upside down. This is handy if you mix a bunch of paint and need to wait between coats.
- If using a glass or ceramic palette, be sure to clean away dried paint before putting out fresh paint, or you will get flecks of dried paint in your work.
- To clean a glass palette, simply spray the dried paint with water and let it sit for a few minutes. The paint will buckle and scrape away easily with a putty knife. Wipe it off with a paper towel or scrape it into the trash.
- Be sure to wash your brushes with brush cleaner or soap and water each day when you finish painting with acrylics. The residue left from merely rinsing your brush in paint water can dry and ruin your brushes.

Mixing Reds

Quinacridone Rose (QR) is a cool version of red, which is usually a warm color. Adding a little yellow (AY) to it will make more of a true red; add a little more and it will make more of an orange-red. And mixing a little blue (PB) with red (QR) will make a violet-red.

Mixing Blues

Phthalocyanine Blue (PB) is an extremely potent color, and it takes very little to have a big color impact. It can easily overpower all the other colors if you use too much. So take the teeniest speck of it and mix it with a little of the red (QR) to turn this cool blue into a warmer, more ultramarine blue. And then mix the teeniest amount of the blue (PB) with yellow (AY) to get a nice vibrant greenish blue.

Mixing Yellows

Azo Yellow (AY) is a semitransparent color because yellow paint always has some white in it, which is an opaque color. You can mix a bit of red (QR) with the yellow (AY) to make a warmer yellow, and you can mix a little blue (PB) with yellow (AY) to make more of a greenish yellow.

Secondary and Tertiary Colors

When you mix two of the primary colors together, you can make secondary colors. The amounts of each will determine the shade and intensity of each secondary color. In theory, mixing half and half of each color should result in a true secondary color. But then you have a color like PB, which will overpower other colors if you use too much. So it all depends upon the paint color and the pigment load. Tertiary colors are the result of mixing primary colors with their adjacent secondary colors to get more shades of each.

Generally it goes like this:

QR + AY = orange
orange + QR = red-orange
orange + AY = yellow-orange

QR + PB = violet
violet + QR = red-violet
violet + PB = blue-violet

AY + PB = green
green + AY = yellow-green
green + PB = blue-green

Adding Black or White

To darken a color, you can add a bit of black to it. However, it can also cause a color shift. For example, adding black to yellow will result in a moss green color. You can add a bit of white to colors to lighten them, and it takes very little to turn bright colors into pastels. Titanium White is an opaque color that changes transparent paints into opaque ones. (More about this on page 86.)

Complementary Colors

This color wheel was developed using the primary, secondary and tertiary colors. Note how bright and clear the colors are. To make more subdued colors, you can add a bit of each color's complement. The complement of each color is directly across the color wheel from the original color. For example, the complement of red is green. If you add a bit of green to red, or vice versa, the color becomes more subdued, less bright. It essentially makes more of a neutral version of the original color. The more you add, the more neutral it becomes until you have a brown or a gray color.

Painting with Opaque Paints

When a paint color is opaque, it blocks out what is beneath it. It covers over other colors including the white of your board. One way to paint your clay work is to paint Ivory Black (or another dark color) over your entire image and then paint on top of it with opaque colors. The opaque paint sits on top of the black surface in contrast, giving it kind of a flat folk-art look.

If you mix a very tiny bit of Titanium White into your opaque paint when applying it over black, it will cover better and look brighter. With this method, the black paint needs to be as dry as possible. Be sure to wipe your brush dry of water before dipping it into your paint. You can also create opaque paints from transparent paints by adding a bit of white to them. For example, mix red (QR) with yellow (AY) to make orange and add a bit of white to make it opaque.

Once you have a color ready to add to your clay work, rinse your brush, wipe it dry and take a bit of the paint mixture onto the edge of your brush. Stroke it on your palette to distribute the paint evenly across the tip of your brush. Be sure there is not a glob of paint on the underside of your brush. Brushing across the detail strokes in your image will help keep the paint from getting into the indentations. So if your lines go one way, you want to stroke across them. This will keep the paint on the surface only, while the indentations remain black.

If you get paint into the indentations, you have too much paint on your brush or it is too runny. Once again, two thin coats are better than one thick one. Wet a towel and wipe away the paint, being sure to get it out of the indentations. Use a wet brush if necessary. Dry your work and begin again.

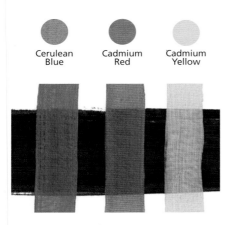

Cerulean Blue Cadmium Red Cadmium Yellow

Opaque Swatches Over Black
When you add a tiny bit of Titanium White to an opaque paint color, it helps make it even lighter so it will cover the black and bring out the contrast.

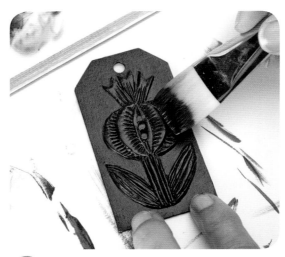

1 Prepare a mini board with gesso and acrylic medium and let it fully dry, then paint it completely with Ivory Black and let it dry.

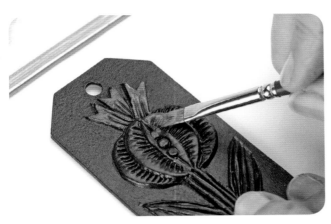

2 Create a mixture of Cadmium Red and a tiny bit of Titanium White. Using a flat brush, paint across the detail strokes of the flower to cover the surface, leaving the indentations black.

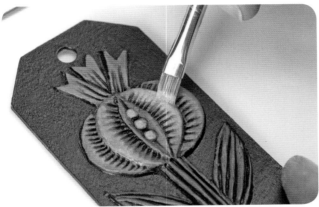

3 Apply opaque orange to the surface of some of the smaller areas as a highlight. Here a bit of opaque orange is rubbed over the red paint to add more interest. Paint the stem and leaves with an opaque green, leaving the indentations showing for added interest. You can add a lighter green color over that as a highlight.

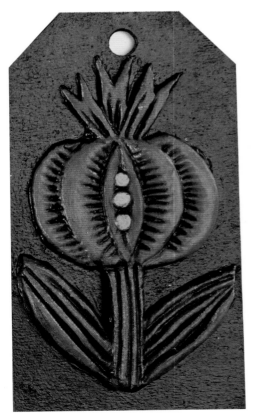

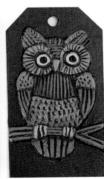
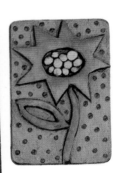
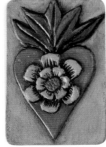
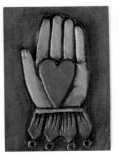
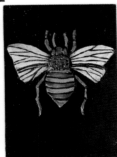

Opaque Painted Mini Boards
These mini boards were painted with opaque colors over black paint. I added a tiny bit of white to each color to help brighten it.

Painting with Transparent Paints

Transparent paints are see-through, allowing the color beneath them to show. Light goes through the paint and hits the color beneath it and bounces back. This gives transparent paints a brighter, livelier look than opaque paints. By the same token, transparent paints do not appear as strong and deep as opaque paints. Because they are see-through, transparent paints are perfect for painting over white clay work that has had the black paint removed from the surface. The black in the indentations will still show through, while the white is colored by the paint.

For this example, begin with a practice project that has been painted black with the paint removed from the surface, then add transparent washes. To have the most control over a wash, rinse and wipe your brush dry to avoid having too much water in your brush. When you paint on a color wash, notice that the black in the details remains visible, and the transparent paint on the surface allows the white underneath to illuminate the color.

You can thin opaque paint to a watery wash with medium or water and use it as a transparent. It will never be completely transparent, but when thinned down, it almost works the same way.

Phthalocyanine Blue Quinacridone Rose Azo Yellow

Transparent Paint Swatches Over Black
When transparent colors are painted over black, they do not cover the color beneath them. Yellow, however, is made with white so it can never be completely transparent. Some yellows are more transparent than others.

Transparent + White Paint Swatches Over Black
Adding a tiny bit of white paint to transparent colors makes them more opaque and better able to cover the colors beneath them. But it also slightly alters the colors by making them a bit more pastel.

The Right Paint for the Job

When painting small, broken-up areas of color, transparent paints work great. When painting a larger area such as a background, where you want the same color and consistency, opaque paints work best.

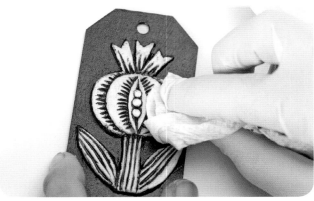

1. Prepare a mini board with gesso and acrylic medium and let it fully dry. Paint it black, and once dry, remove the black paint from the surface with rubbing alcohol.

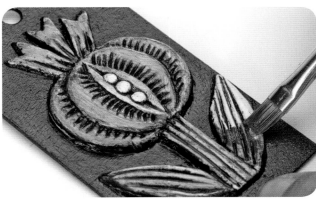

2. Paint your image with thin layers of a transparent purple wash (red mixed with a bit of blue). For best results, allow paint to dry and cure for twenty minutes between layers.

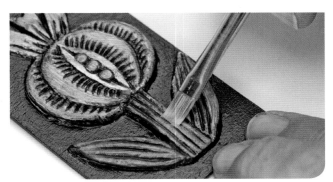

3. When the paint is dry, glaze over the top with washes of other colors. Here yellow is applied over blue to make a bright green for the stem and leaves. Paint the center seeds with red.

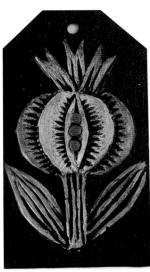

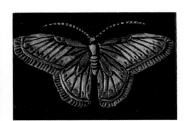

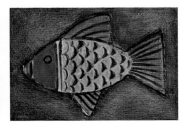

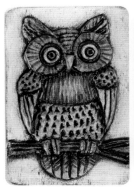

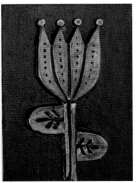

Transparent Painted Mini Boards
These mini boards were all painted with transparent colors over white paint (except for the black backgrounds, of course).

 # Adjusting Colors

Sometimes when painting clay work it can feel rather heavy and lifeless. Or maybe you painted a color that looks flat or that you don't like. Never fear: You can adjust any color, be it opaque or transparent, by painting over it with a transparent glaze or a bit of opaque paint. You can also remove paint with rubbing alcohol and then repaint it. Below you will see how to alter, enhance or add life to colors.

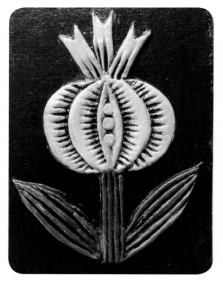

Problem: Too Boring
This mini board was painted with solid opaque paint and feels boring.

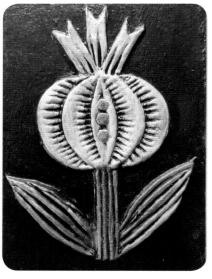

Solution: Add Transparent Glaze
Add transparent glazes to bring life to the underpainting.

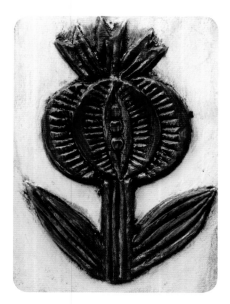

Problem: Too Heavy
This mini board looks heavy and dark because it was painted with lifeless colors.

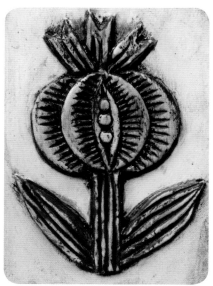

Solution 1: Remove Paint
Remove some of the heaviest paint with alcohol.

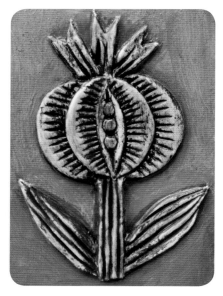

Solution 2: Add a Transparent Glaze
Then add a transparent glaze using a complementary color.

 # Tints and Washes

The look of the clay work when the black paint has been removed can be very interesting. Sometimes you may want to keep it that way, or maybe you want to add a neutral color to it to give it a primitive, tribal or antique effect. Below you will see how to add monochromatic color and enhance the clay work with shading.

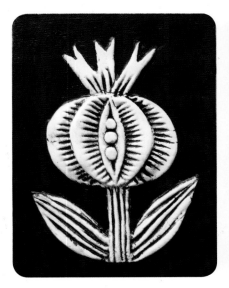

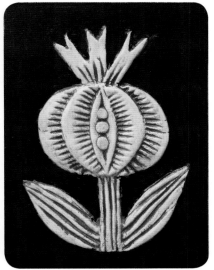

Problem: Too Stark
This black-and-white mini board looks a bit too stark in contrast.

Solution: Add a Sepia Tint
Add a tint of transparent brownish sepia over the entire image, and to get highlights, rub away some from the surface before it dries.

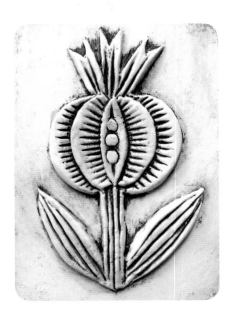

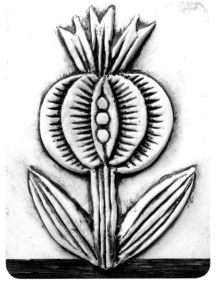

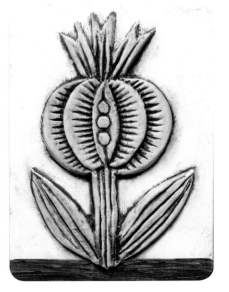

Problem: Washed Out
This mini board was painted with brown, but after removing the paint, it looks a bit washed out and lacks definition.

Solution 1: Add a Black Wash
Using a detail brush and brown wash, paint around the edges of the clay to emphasize depth and create shadows.

Solution 2: Add an Antique Wash
Then add a thin wash of blue-green to the flower and leaves to add a pop of overall color.

Leafing Out

For this first project you will paint with both transparent and opaque paints. The leaves in the upper left and lower right were painted with transparent paint over white, while the other two were painted with opaque paint over black. Notice how bright the transparent colors appear. This is because the light goes through the color, hits the white and bounces back.

MATERIALS

❋ Project 1 finished clay work (pg 46)

❋ Finishing Techniques Toolkit (pg 11)

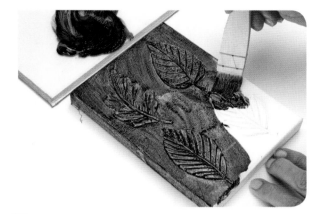

1 **Paint the Clay Work with Gesso and Medium**
Paint your clay work with two thin coats of gesso. Allow each coat to dry and cure before applying the next. Use a hair dryer to speed up the process. When the gesso is dry, paint your artwork with two coats of gloss medium. Do not let the medium pool. Keep brushing it until you have a smooth coat. Once dry, add a second coat. Allow it to dry and cure for 20 minutes or speed it up with a hair dryer.

2 **Cover the Clay Work with Black Paint**
Make a soupy mixture of Ivory Black paint and water, enough to paint over your entire piece. Apply the paint with a soft brush and swirl it into all the crevices of your artwork so that you see no white. No need to make the paint solid at this point. Allow it to dry completely.

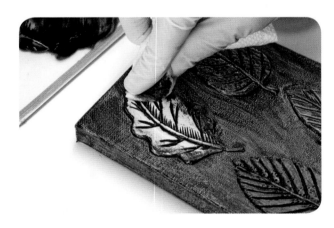

3 **Remove Paint from Two Leaves**
Using rubbing alcohol and a paper towel, remove the paint from the surface of the leaves at the top left and the bottom right of your piece, leaving the other two black. You might end up lifting some of the black from the background as well. Good reason not to paint it solid in the first place.

LEAFING OUT
Paper clay and acrylic
on canvas
7" × 5" (18cm × 13cm)

Turn to page 46 for instruction on creating the unpainted clay work for this project.

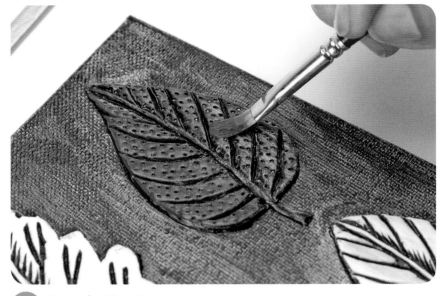

4 Mix a Green

Using a flat brush, mix a bit of Cadmium Yellow and Phthalocyanine Blue to make a midtoned green color. Do not add any water to the paint. Begin with the leaf on the upper right side.

5 Paint the First Green

Using very dry paint, brush across the veins of your leaf, rather than in their direction. This keeps the brush hairs sweeping across the surface rather than falling into the crevices. Paint one side a bit lighter than the other by adding a bit more yellow to your green mixture if you like.

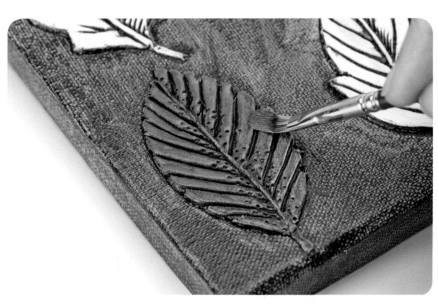

6 Mix a Blue

Wash and dry your flat brush. Mix a bit of Phthalocyanine Blue with a tiny bit of Quinacridone Rose to make it more blue and less turquoise. Then add a bit of Titanium White to make a midtoned blue color.

7 Paint the Second Leaf Blue

Paint the leaf on the lower left side using the same technique and dry blue paint.

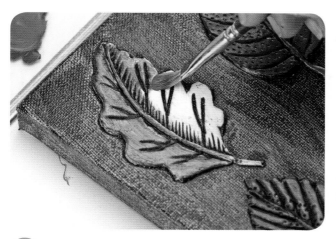

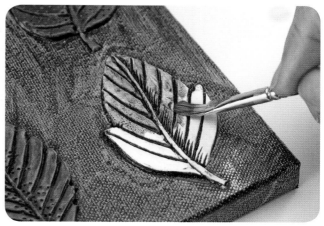

8 **Mix a Red and Paint the Third Leaf**

Using a flat or filbert brush, mix a bit of Quinacridone Rose with a bit of Azo Yellow to make a red color. Make a wash from it by adding a bit of water. Using a clean dry brush, glaze the leaf on the upper left side with the red color. The trick to glazing is to get an even coat with minimal streaking.

9 **Mix a Plum and Paint the Fourth Leaf**

Begin with a bit of Quinacridone Rose and add a tiny bit of Phthalocyanine Blue to create a medium plum color. Add water to make a wash. Using a clean dry brush, glaze the leaf on the lower right side with the plum color and minimize streaking by stroking it a few times with the color.

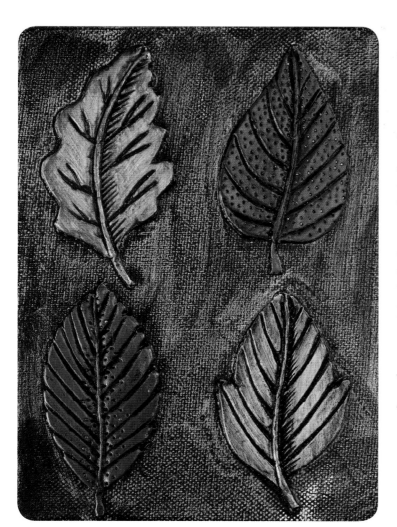

10 **Complete the Underpainting**

All the leaves are painted, but it looks pretty uninteresting, right? This is where glazing with transparent paint adds spice to bland colors. The underpainting must be completely dry and cured before continuing. You can either wait 20 minutes or use a blow dryer to dry the paint and heat the surface to speed curing. Then you can begin adding glazes of color over the top to enhance and enliven the base colors.

I often compare looking at color to eating chocolate. If you were to eat a spoonful of plain cocoa powder, it would not taste very good. But add some sugar and cream and you have a much more appealing taste to the tongue. A plain color, by the same token, is more appealing to the eye when it is made richer with other ingredients like glazes of additional tones and hues.

Keep Your Paint Moist

To keep your acrylic paint mixtures from drying out between coats, place a small plastic container over them, upside down. Small yogurt containers work great.

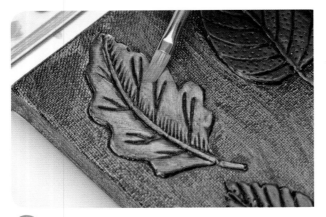

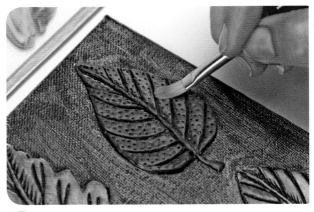

11 **Glaze the Red Leaf**
Starting with the red leaf, glaze the right side with an Azo Yellow wash to make an orange color. The thicker the wash, the more vivid the results. Add a wash of Quinacridone Rose to the left side of the leaf.

12 **Glaze the Green Leaf**
Add a wash of Azo Yellow to the right side of the green leaf. Add a wash of Phthalocyanine Blue to the left side of the leaf.

13 **Glaze the Blue Leaf**
Add a wash of Phthalocyanine Blue with a touch of Azo Yellow to the left side of the blue leaf making it more of a green color. You still want to see some of the color from underneath showing through.

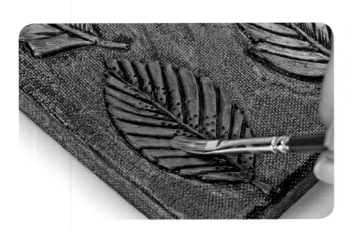

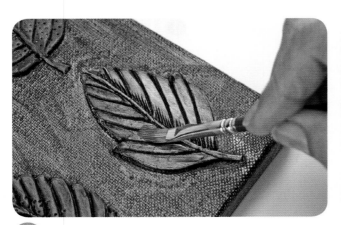

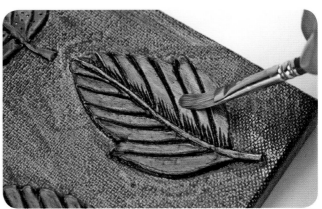

14 **Glaze the Left Side of the Plum Leaf**
Add a wash of Quinacridone Rose to the left side of the plum leaf making it more of a violet color.

15 **Glaze the Right Side of the Plum Leaf**
Add a wash of Phthalocyanine Blue to the right side of the same leaf making it more of a purple color.

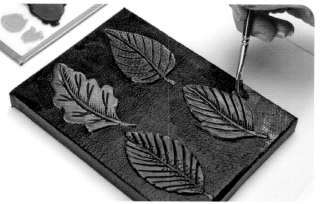

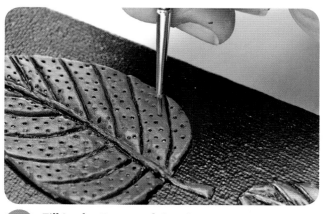

16 **Paint the Background and Sides of the Canvas**
Once everything is dry, paint your background and the sides of your substrate with Ivory Black. Use a medium-size brush and a detail brush to get in all the tight places. Thin the paint with enough water to make it flow and paint two thin coats, allowing the first one to dry before applying the second. Smooth out any paint ridges you might see.

17 **Fill In the Dots and Crevices**
Once everything is dry, you can use a wash of Ivory Black to glaze over areas that may have filled with opaque paint. Let the black wash settle into the indentations and then wipe the surface with a slightly damp paper towel.

18 **Enhance with a Black Wash**
You can enhance the sculptural look of the clay work by adding a stroke of black wash to the center of each leaf, taking care not to get it on the center vein. Remove excess with a paper towel or a clean wet brush.

19 **Varnish the Piece**
Let your piece dry for at least 20 minutes before applying a final coat of medium as a varnish. You can paint the background and sides with matte medium and the leaves with gloss medium if you like.

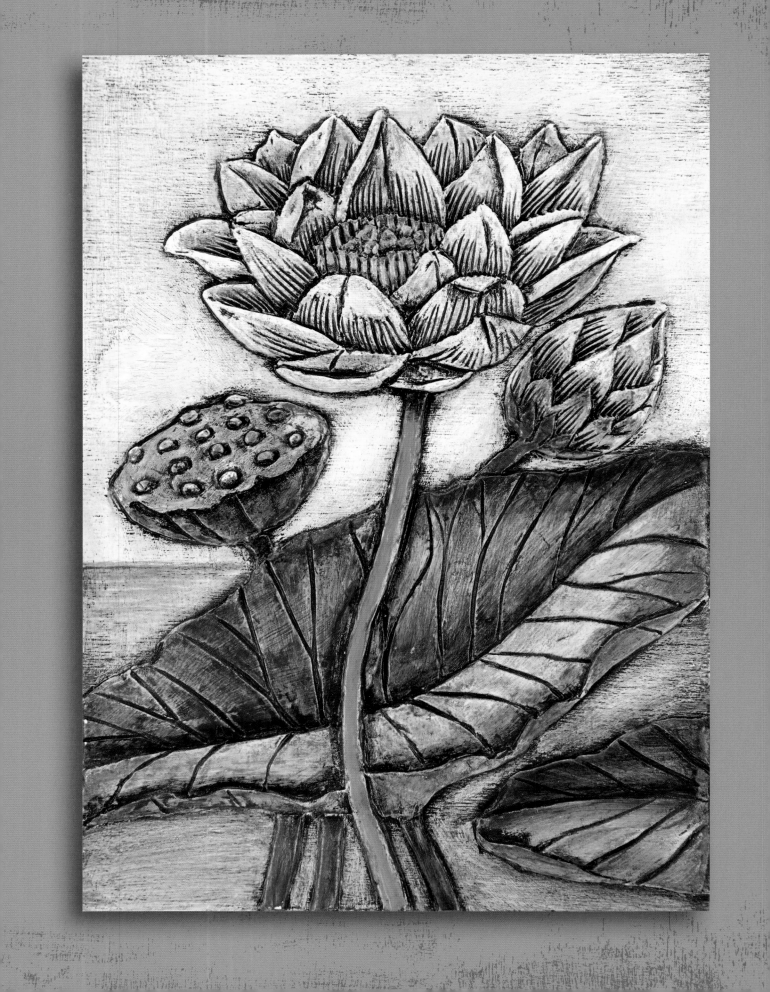

Lotus Lilies

This project is painted with all transparent paints and perfect for applying subtle glazes that bring an image to life. To make pastel colors such as the flower color, you will apply thin layers of paint so that the white of the board and the color of the paint mix visually. With this method, the artwork nearly glows because the light goes through the paint, hits the white of the board and bounces back to your eye.

MATERIALS

✤ Project 2 finished clay work (pg 52)

✤ Finishing Techniques Toolkit (pg 11)

1 Paint the Clay Work with Gesso and Medium
Paint your clay work with two thin coats of gesso, allowing each coat to dry before applying the next. When the gesso is dry, paint your artwork with two coats of gloss medium and allow each layer to dry. Take care not to let the gesso or medium pool in any areas of your artwork.

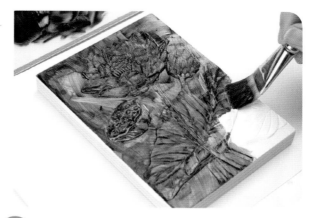

2 Cover the Clay Work with Black Paint
Make a soupy wash with Ivory Black and water. Paint over your entire artwork including the sides with the wash, making sure to get into every nook and cranny. No need to paint everything solid black.

3 Remove the Paint
Once your piece is dry, use alcohol and a clean paper towel to remove the black paint from the surface of the clay with gentle strokes. Remember to fold your towel so that you are always using a clean area.

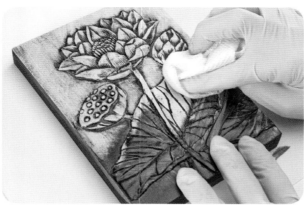

LOTUS LILIES
Paper clay and acrylic on wood panel
7" × 5" (18cm × 13cm)

Turn to page 52 for instruction on creating the unpainted clay work for this project.

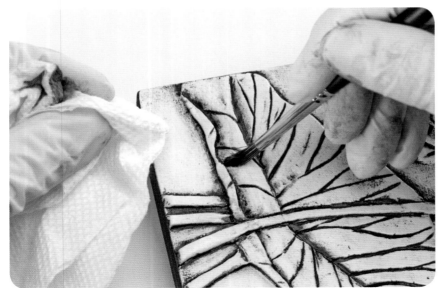

 Use a Brush in the Small Crevices

If there are places where the black paint is hard to remove, use a stiff small filbert or round hog brush dipped into alcohol and rub gently around those areas. Blot with the fold of a paper towel.

5 **Complete the Background**

Continue removing the black paint from the entire background. The idea is for the clay and background to be white, not gray. A certain amount of black paint residue will remain in the tiny crevices of the board itself, which is a desirable characteristic of paint removal.

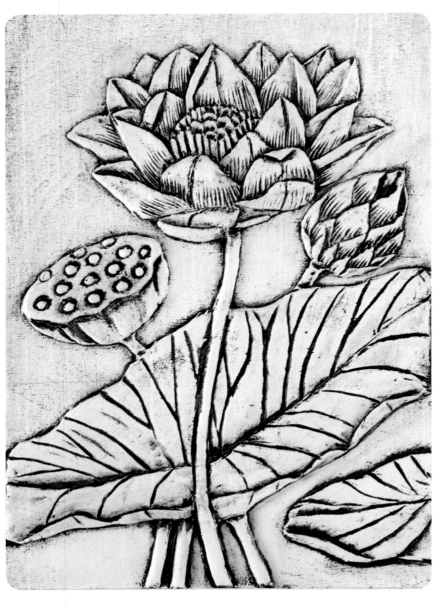

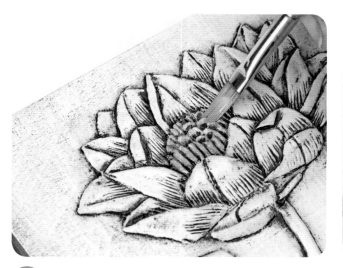

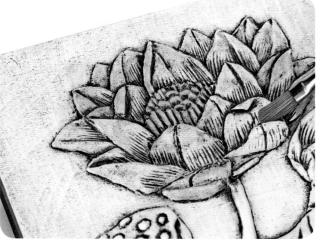

6 Paint the Flower's Center

Make a thin wash of Azo Yellow and add a tiny bit of Quinacridone Rose to make a warm yellow. Wipe your brush dry, pick up a bit of the color and glaze the center, or stamen, of the flower.

7 Paint the Flower and Bud

Make a thin wash using a small amount of Quinacridone Rose and a speck of Azo Yellow to make it a warm pink color. Wipe your brush dry, then glaze the entire flower and bud with a light coating of pink.

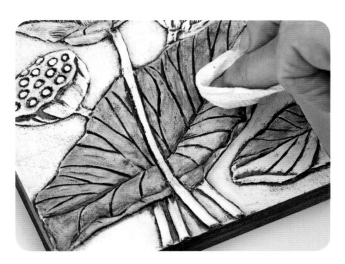

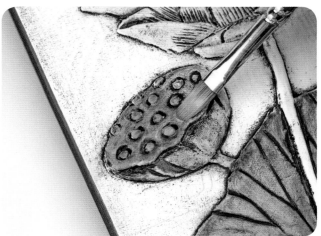

8 Paint the Leaves

Make a thin wash using Hooker's Green, wipe your brush dry, pick up a bit of paint and glaze both leaves. Avoid the stems for now. Using a paper towel, blot some of the paint from the bottom of both leaves while the paint is still wet to create a highlight.

9 Paint the Pod and Bud

Using the same wash of Hooker's Green, paint the base of the pod and the base of the bud with a light coat. Then add some Azo Yellow to the green wash to make it more yellow-green and glaze the top of the pod.

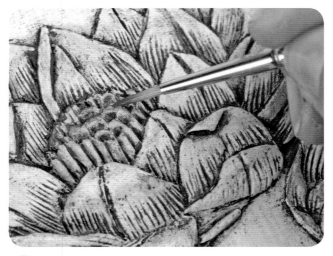

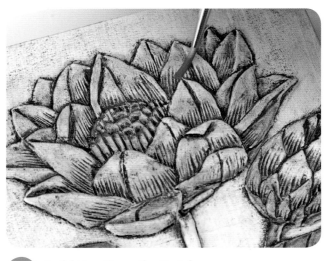

10 **Add Color to the Flower's Center**
Using Quinacridone Rose and a detail brush, paint the tips of the stamen in the center of the flower to add some interest to this focal point.

11 **Build Depth on the Petals**
Using a bit of Quinacridone Rose, mixed with a bit of Azo Yellow, make a warm red wash. Wipe your brush clean, pick up some of the red wash and paint the base of each petal to deepen the color, giving more depth to those areas. Do the same to the base of the petals on the bud.

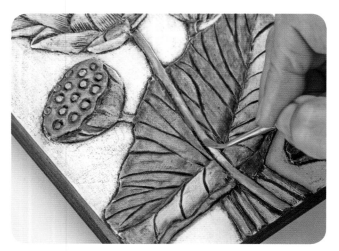

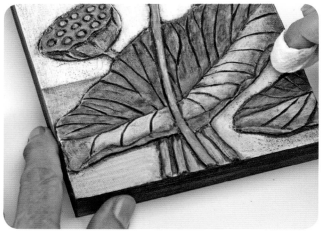

12 **Paint the Stems**
Make a thin wash with Hooker's Green and glaze all of the stems except the one belonging to the main flower. This one should be lighter than the leaf it goes over. Mix some Azo Yellow with the green wash and make a light yellow-green wash for glazing the main stem.

13 **Paint the Water and Clean Up the Background**
Make a thin wash with Phthalocyanine Blue and a bit of Quinacridone Rose to make an aqua color. Glaze the water area and then blot the center of each area with a paper towel to lift the paint and create a highlighted area.

If you have gotten any paint on the background, clean it with a bit of alcohol and a paper towel, using a brush in tight areas.

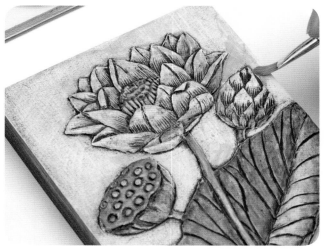

14 Paint the Sky

Make a thin wash of Azo Yellow with the tiniest bit of Phthalocyanine Blue to make a very light chartreuse-green. Paint the background and blot off the excess so it is very light.

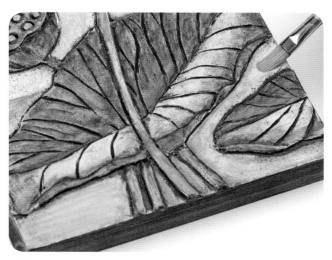

15 Glaze the Water

When the water is dry, glaze over it with a very thin, light wash of Azo Yellow. This will integrate the sky with the water. Blot the excess.

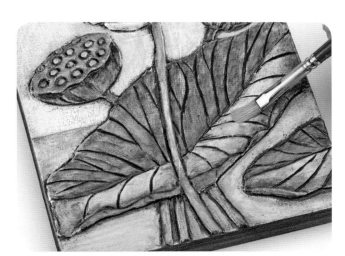

16 Paint the Background and Sides of the Canvas

Use the same wash of Azo Yellow and glaze over the leaves. This will warm the highlights and integrate the leaves with the sky and the water.

Paint the edge of the board with two more coats of Ivory Black. Use a wet paper towel to immediately wipe away any paint that gets on the edge of the art.

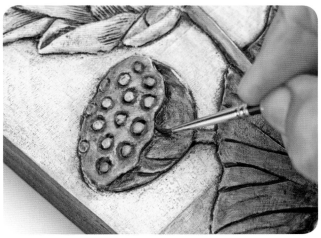

17 Enhance with Black and Apply Varnish

Use a light wash of Ivory Black to accentuate areas with shadowing, such as under the top of the pod, along the center crease of the leaves above the highlight, under the flower and the base of some of the flower petals and along the stem of the main flower.

When everything is dry and you are happy with the color, paint everything with matte or gloss medium, depending upon what you prefer. Take care not to let the medium pool anywhere.

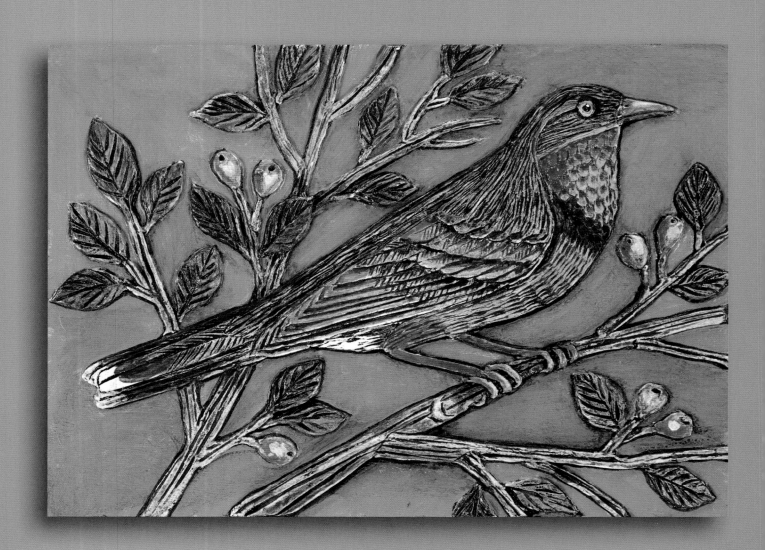

FRIEND OF A FEATHER
Paper clay and acrylic
on wood panel
5" × 7" (13cm × 18cm)

Friend of a Feather

This project was inspired by the vintage illustration of a Varied Thrush seen on page 58. The clay work is painted overall with dark brown instead of black, which creates less contrast and a softer look. The foreground is painted with transparent paint, while the background and a few highlights are done with opaque paint.

MATERIALS

❀ Project 3 finished clay work (pg 58)

❀ Finishing Techniques Toolkit (pg 11)

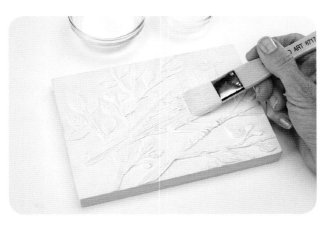

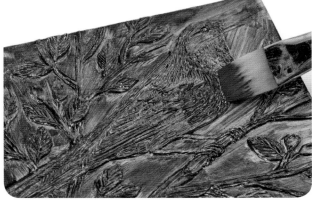

1 **Paint the Clay Work with Gesso and Medium**
Paint with two thin coats of gesso followed by two thin coats of gloss medium to prepare for painting. Allow each layer to dry completely. Take care not to let any gesso or medium pool in any areas of your artwork.

2 **Cover the Clay Work with a Dark Wash**
Mix a small amount of Burnt Umber with Ivory Black in equal portions. Add water to make a wash that flows easily. Paint your entire artwork and allow it to dry completely. Be sure to get every nook and cranny.

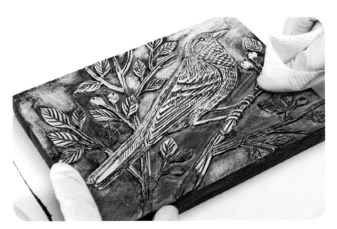

3 **Remove the Paint**
Once dry, use paper towels dipped in alcohol and begin removing the brown paint from your artwork starting with the bird. Use light strokes and constantly turn your paper towel so the surface remains relatively clean. If the paint is difficult to remove among the leaves and branches, dip a small brush into alcohol to reach those areas, rubbing gently and blotting with a paper towel.

Turn to page 58 for instruction on creating the unpainted clay work for this project.

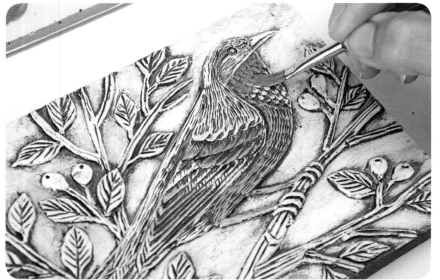

4 Paint the Bird with Orange

Make a thin reddish-orange wash using Azo Yellow and Quinacridone Rose in somewhat equal portions. Glaze the areas of the bird that are to be orange, including the eye swoosh, the breast, the underside and parts of the wing tips as shown.

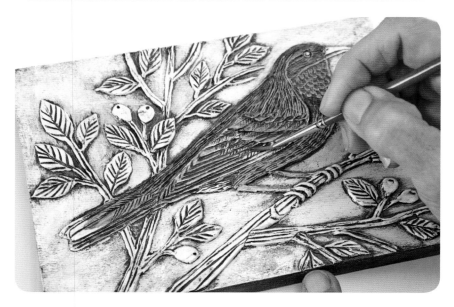

5 Paint the Bird with Light Brown

Make a thin wash of Burnt Umber and glaze the parts of the bird that are brown, taking care to avoid the tips of the tail and the back part of the underside that will remain white.

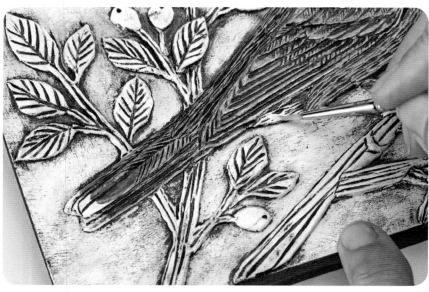

6 Touch Up with White

Using a detail brush, paint a bit of opaque Titanium White over the areas that are to remain white, taking care to brush across the grain of the detail.

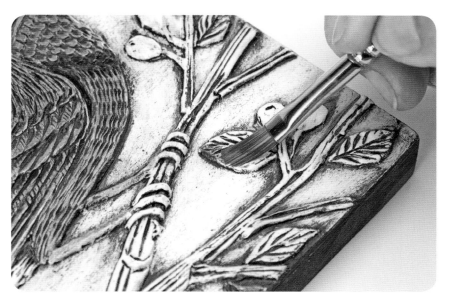

7 Paint the Leaves

Using a small amount of Hooker's Green, make a second wash with a bit of water. Glaze over each leaf. Add interest by glazing a wash made from Azo Yellow over the top half of each leaf if you like.

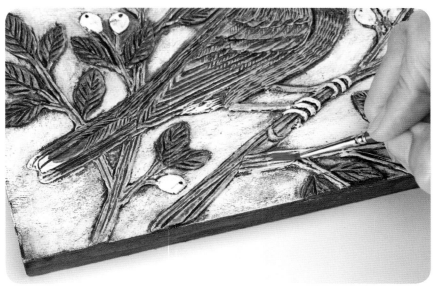

8 Paint the Branches

Make a thin wash of Azo Yellow with a tiny bit of Burnt Umber and glaze the branches. Since the branches are already brown in the crevices, you can use a tan wash to color them, which allows the detail strokes to show.

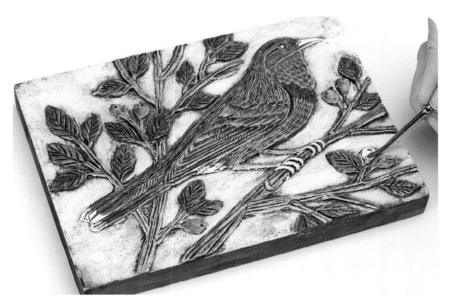

9 Paint the Berries

Make a wash using a tiny bit of Quinacridone Rose and even less Azo Yellow to make a reddish color for the berries (which are actually crab apples). Glaze each berry.

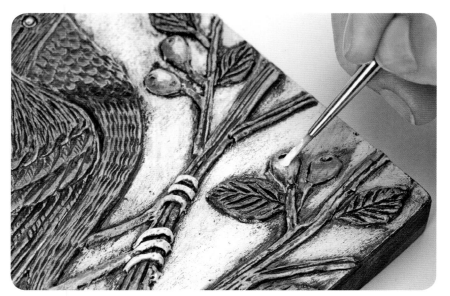

10 Add Highlights

On top of each berry, where the light hits, would be a shine spot. You can mix some white with the berry wash color to make a light pink and paint on the color, or you can use alcohol to remove some of the berry color, revealing a bit of the white underneath.

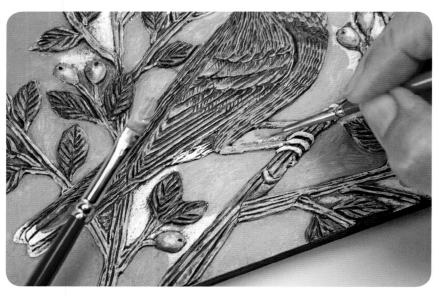

11 Paint the Background

Once all the clay work is painted, add color to the background. Mix Titanium White with a tiny bit of Phthalocyanine Blue and then add a tiny bit of Quinacridone Rose to make a sky blue color. Thin this opaque paint with a dab of water to help it flow. Make enough for two coats. Use a medium-size filbert brush to apply the paint to broad areas and a detail brush to get between the leaves and branches. Brush the surface to make it smooth without leaving ridges of paint.

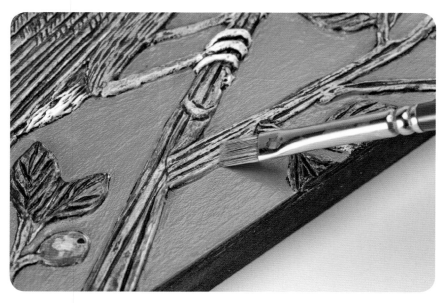

12 Use a Wet Brush to Remove Paint

You may get paint where you don't want it. Use a clean, wet brush to kind of scrub the area and blot to remove the paint. This works because the rest of your artwork is dry. Allow this layer to dry and cure for 20 minutes. Thin the blue paint with a bit of water and glaze over the entire background with a second coat. Remember to cover your paint to keep it from drying out while waiting for the first coat to dry.

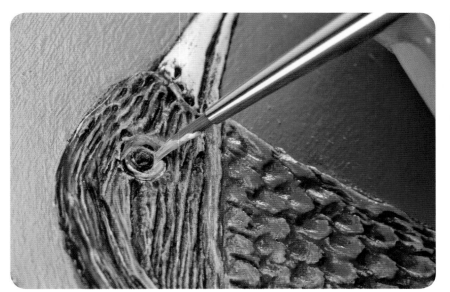

13 **Paint the Eye**
The eye is the focal point and needs to be painted carefully. Mix a tad bit of Cadmium Yellow with Titanium White to make a light yellow color. Using a no. 00 or no. 000 detail brush, paint the outer circle of the eye. For better control, do not make the paint watery and blot your brush dry before applying the paint.

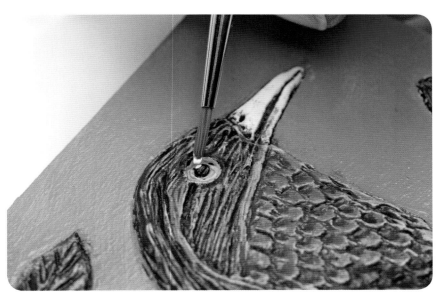

14 **Highlight the Eye**
Paint the center of the eye Ivory Black. Once it is dry, paint a tiny speck of white as a highlight on one side of the iris with Titanium White. Do not add water to the paint so that it is as opaque as possible.

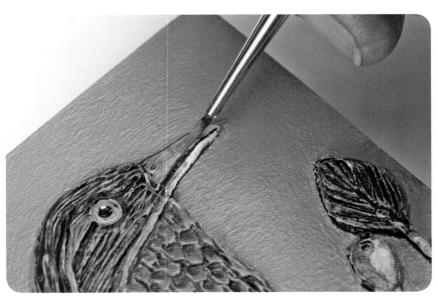

15 **Paint the Beak**
Using a bit of Ivory Black and Titanium White, make a medium gray color and paint the beak. Add more white to the gray color to make a very light gray. Add a light gray highlight to the top of the beak.

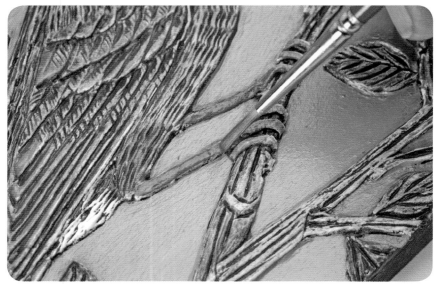

16 Paint the Legs and Feet
Mix a bit of Quinacridone Rose to Azo Yellow to make an orange color and glaze over the legs and feet. Once dry, glaze over them again with a wash of the medium gray you made for the beak.

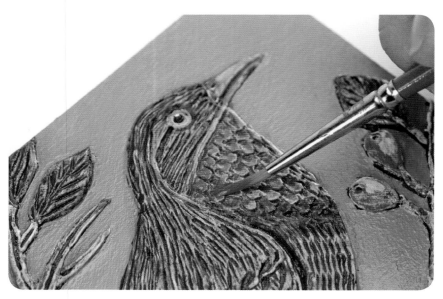

17 Add Deep Orange Accents
Mix Quinacridone Rose and Azo Yellow to create a deep red-orange accent color to enhance the breast and underside of the bird.

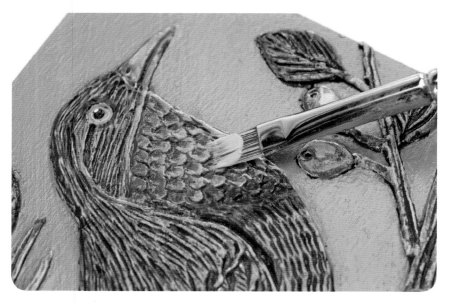

18 Highlight the Breast
Mix a dab of Cadmium Yellow with a tiny bit of Quinacridone Rose to make a light orange opaque paint. Do not add water to it. Using a flat brush, take a bit of the color and rub it lightly to the top of the breast feathers to add a highlight to the area.

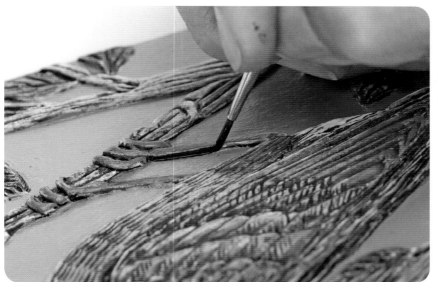

19 **Touch Up with Dark Brown**
Make a mixture of Burnt Umber and Ivory Black as before. Using a detail brush (no. 00 or no. 000), paint the edges of clay work where any unwanted blue paint may have gotten. You can also use this color to deepen areas that might be shadowed, such as the branch next to where the bird's feet are clasped and the branch behind the tail.

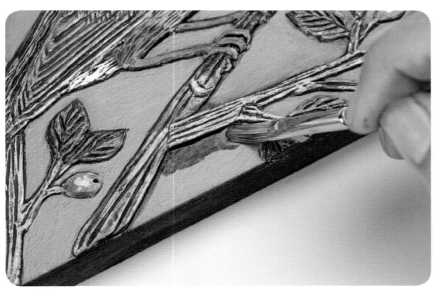

20 **Add Antique Glazing**
At this point you could be finished painting. Or you can make a wash from the dark brown paint mixture and antique the background. This helps the opaque background color integrate with the foreground clay work. Paint the wash on small areas and wipe it away with a dry paper towel, leaving just a hint of brown.

21 **Build Depth on the Petals**
You may want to use a second brush moistened with water to soften any hard edges from the brown wash, and blot them with a towel.

To finish the piece, paint the edges with two coats of the dark brown mixture and a flat brush, letting the first coat dry before adding the second. Sign your work with a detail brush. When everything is dried and cured, paint the entire image and sides with the medium of your choice.

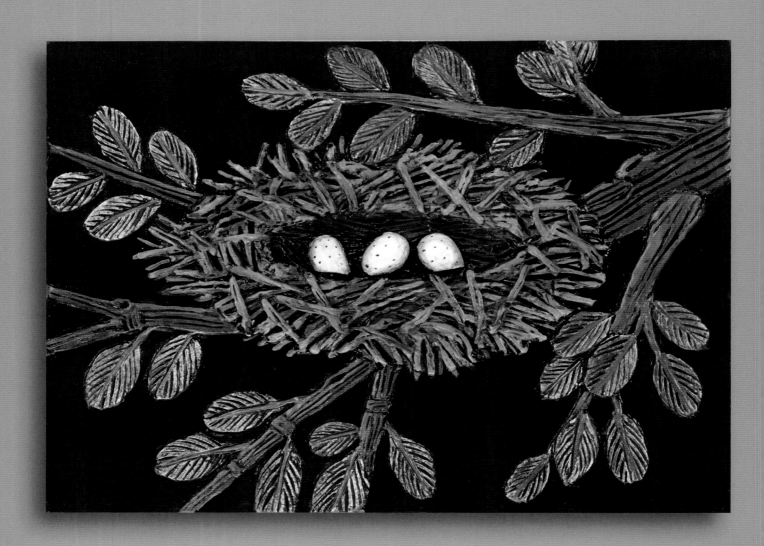

NESTING
Paper clay and acrylic
on wood panel
5" × 7" (13cm × 18cm)

Nesting

This project is mostly painted with opaque paints. Everything is painted black except the eggs, which are painted white. And the black paint is removed only from the leaves. Opaque paint is applied over the black paint. It is extremely important to keep your brush blotted and dry when painting this way. If the paint is runny, it will get into the recessed areas and won't cover the surface color very well.

MATERIALS

✤ Project 4 finished clay work (pg 66)

✤ Finishing Techniques Toolkit (pg 11)

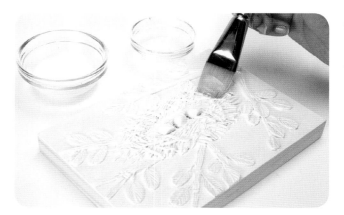

1 Paint the Clay Work with Gesso and Medium

Begin by painting your entire clay work with a coat of gesso. When it is dry, paint all the leaves with gloss medium so you can remove the paint from them later.

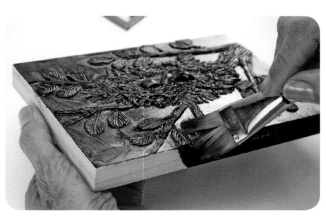

2 Cover the Clay Work with Black Paint

When the gloss medium has dried and cured for 20 minutes, paint everything with a wash of Ivory Black including the sides of the board. Turn your board to be sure you have gotten the wash into every area. Use a detail brush if needed to cover every speck of white.

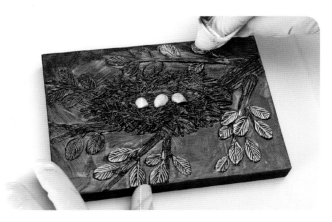

3 Remove Paint From the Eggs and Leaves

When the black paint is dry, remove it from the eggs and surface of the leaves with alcohol and a paper towel. Be sure to turn your towel often so you are using a clean surface. You will be repainting the background, so don't worry about accidentally removing paint from those areas.

Turn to page 66 for instruction on creating the unpainted clay work for this project.

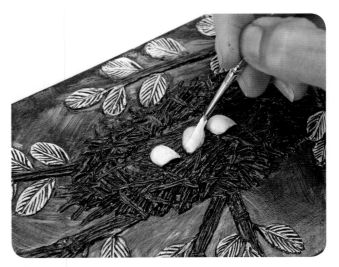

4 **Paint the Eggs White**
Paint the eggs with Titanium White. Use a detail brush to reach down into tight areas. Touch up with black as needed.

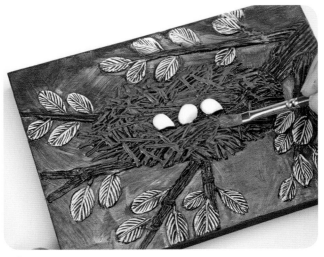

5 **Paint the Nest with a Base Color**
Make a medium brown paint color by mixing Burnt Umber with a bit of Cadmium Yellow and Titanium White. Do not add water to the paint. Using a medium flat or filbert brush, take a small amount of the paint mixture and be sure it is evenly distributed along the edge of your brush without any paint blobs lurking on the underside. Stroke your brush across the fibers of the nest to hit the tops of them with paint. Save the remaining paint.

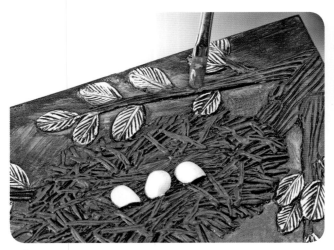

6 **Paint the Branches with a Base Color**
Make a reddish brown paint color by mixing Burnt Umber with a bit of Cadmium Red and Cadmium Yellow. Do not add water to the paint. Use a flat or filbert brush to paint the branches, stroking across the texturing so the paint does not get into the crevices. Save the remaining paint.

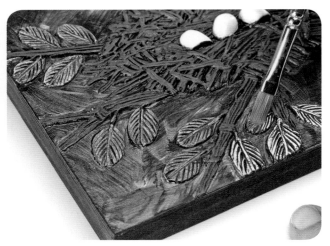

7 **Paint the Leaves with Transparent Paint**
Make a green paint color by mixing Hooker's Green with a tiny bit of Cadmium Yellow. Then add a bit of water to make it into a thin wash. Using your same flat or filbert brush, blot it dry and paint all the leaves green.

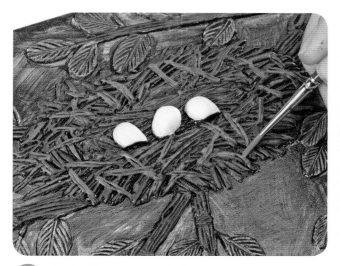

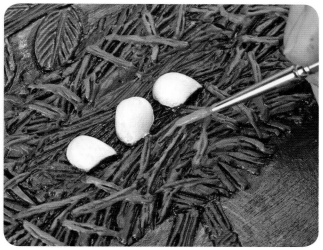

8 **Add a First Accent Color to the Nest**

Now that you have all the base colors painted and they are nearly dry, begin adding lighter accent colors. Mix a tan color by using the same base color for the nest and adding Titanium White to it. Use a detail brush to paint select fibers on the topside of the nest. When painting, always keep a moist paper towel in your other hand so you can blot excess paint or remove mishaps.

9 **Add a Second Accent Color to the Nest**

Take the tan you mixed for the accent color on the nest and add a bit of Cadmium Yellow and Titanium White to it to make it even lighter. Use this to stroke more nest fibers. Eventually it will look like the fibers are a mix of different colors like a real nest. Save the rest of this paint.

10 **Highlight the Branches**

Using the original paint color you mixed for the branches, add a bit of Cadmium Red and Cadmium Yellow to it, making it a dark red-orange color. Using a detail brush, stroke the topside of the branches to add an interesting highlight.

11 **Accent the Leaves**

You can stroke a bit of the red-orange color from step 10 down the center stem of each of the leaves to add interest to them. This also helps to integrate the leaves with the branches.

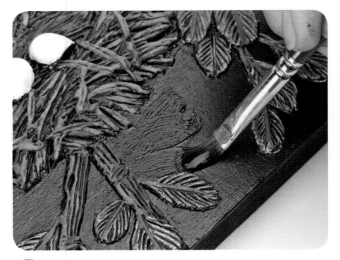

12 Paint the Background Black

Now is a good time to paint the background solid black. Use a detail brush to paint around things and a medium flat or filbert to paint in the broad areas. Use Ivory Black and mix in a little water to help the paint flow. Smooth out your strokes so it has a flat finish with no bumps or ridges. It might take two coats.

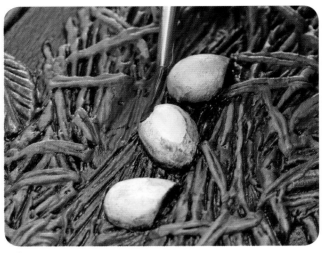

13 Add a Black Wash to the Eggs

The eggs are stark white at this point and need to be integrated into the nest. Make a wash with black and water and paint over each egg with a detail brush, wiping away the excess with a paper towel. The idea is to antique the eggs a bit with the wash. Then paint the base of each of the eggs with the wash so they blend into the nest.

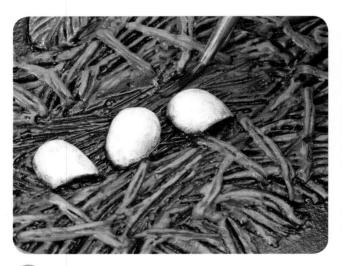

14 Add a Black Wash Inside the Nest

To make the inside of the nest look more sunken, deepen the colors. Use the same black wash to paint the inside of the nest, darkening the lower edge the most.

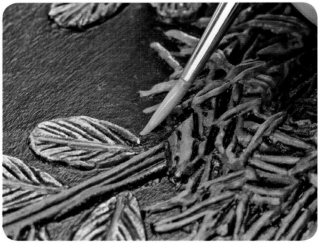

15 Paint the Nest Edges

Now that you have painted the background, you can paint selected fibers along the edge of the nest to make it look more natural and irregular like a real nest. Use the light tan color you made earlier and a detail brush.

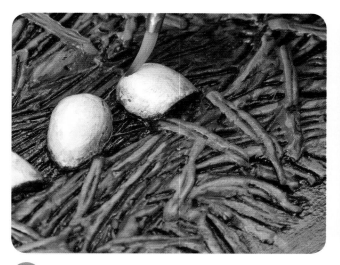

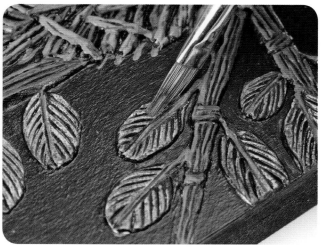

16 **Paint the Eggs With Transparent Blue**
Make a thin wash using a tiny, tiny bit of Phthalocyanine Blue and a tiny bit of Azo Yellow. Use a medium filbert brush and paint each egg, quickly blotting the tops to lighten them. This creates a highlight on the top of the eggs and lightens the overall color.

17 **Accent the Leaves with Blue**
You can use the same transparent blue wash to add interest to the leaves. Use a medium filbert brush and paint half of some of the leaves with the blue wash. This deepens the green color and helps to integrate the eggs with the leaves.

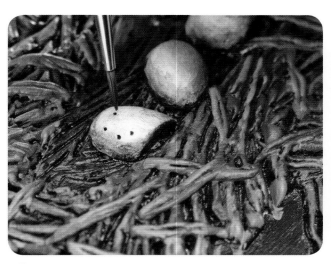

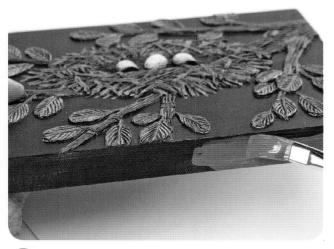

18 **Speckle the Eggs**
Once the eggs are dry, you can add tiny little specks to them using a detail brush and Ivory Black paint if desired.

19 **Paint the Edge of Your Panel**
You can paint the edge of your board black or use a color from your image. A red-orange color will pick up the accent color of the branches. Mix Cadmium Red with Cadmium Yellow to make a desired color. Add a bit of black to deepen it. Paint one coat, let it dry, sand it a bit and apply a second coat.

Check your artwork from every angle to be sure that it is all painted. Sometimes the edges of leaves or branches get missed. You can also use a detail brush to paint black into crevices that filled in with colored paint. When you are finished, let it sit overnight and then paint a final coat of matte medium over everything to protect the finish. Always be careful not to let the medium pool in any corners.

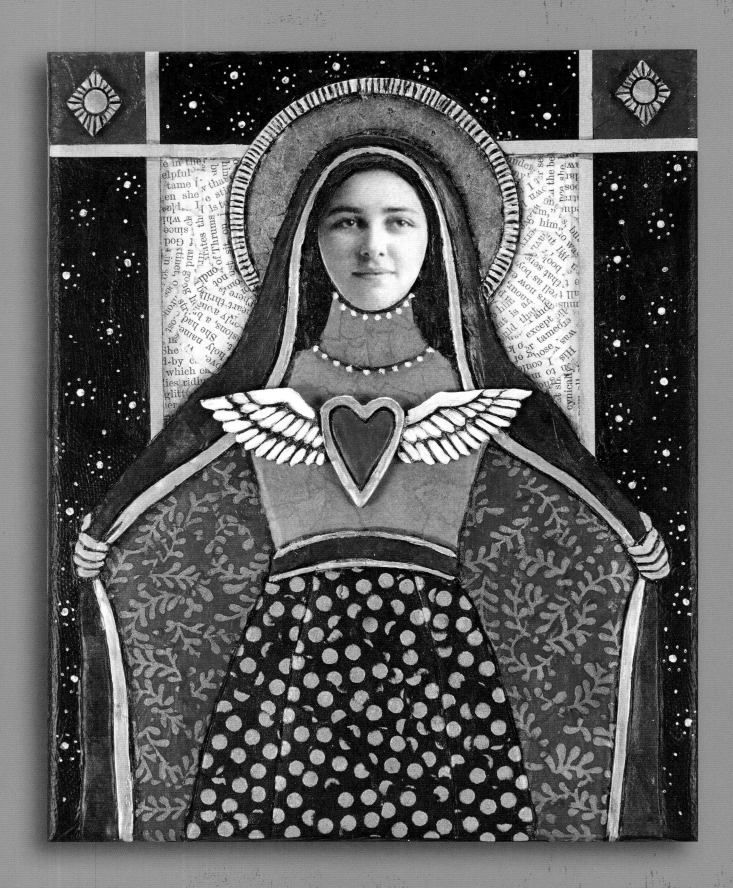

Set Your Soul Free

This project combines painting with collage papering for more of a mixed-media look. The flying heart and corner elements are made as appliqués and glued to the surface after the base art is completed. Generally, when papering over clay work, it is best to do all the painting first so you don't get paint on the papers. However, there is very little painting on this project.

MATERIALS

✤ Project 5 finished clay work (pg 72)

✤ Finishing Techniques Toolkit (pg 11)

✤ collage papers

✤ white craft glue

✤ small plastic container with lid

1 Paint the Clay Work with Gesso and Medium

Coat your clay work with two thin coats of gesso and two thin coats of gloss medium. Make sure to seal the appliqué pieces as well from steps 10 and 11 on page 76. Allow all layers to dry completely.

2 Paint the Face with Medium

Make a laser copy of the template on page 77 and paint over the face with two coats of matte medium to protect it from smudges, paints and glues. Allow the face to dry completely before cutting it out.

3 Cover the Clay Work with Black Paint

Paint the entire clay figure with Ivory Black paint leaving the background white. Paint your flying heart and corner embellishments as well.

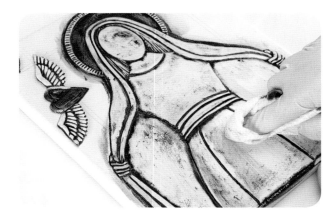

4 Remove the Paint

Using rubbing alcohol, remove the black paint from the surface of the clay. Be sure to turn your towel so that you are always using a clean surface dipped in alcohol for removing the paint. Remove the paint from the heart and corner pieces as well.

OUR LADY OF SETTING YOUR SOUL FREE
Paper clay and mixed media on canvas
10" × 8" (25cm × 20cm)

Turn to page 72 for instruction on creating the unpainted clay work for this project.

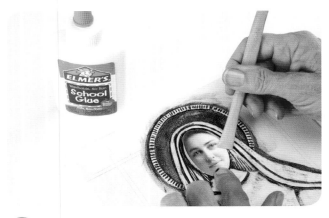

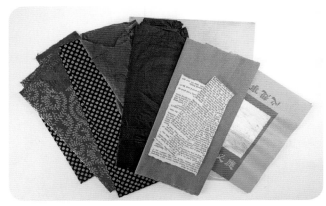

5 **Glue Down the Face**
When the face from step 2 has dried, cut it out using a craft knife or scissors. Glue the face to the saint using white craft glue. Be sure to burnish it flat so there are no air bubbles under it. When using laser copies for collage work, you can also print them on cover stock for added ease in gluing.

6 **Gather Your Collage Papers**
The collage papers I have chosen for this project include handmade printed cotton papers, pages from an old book, metallic gold joss paper from an Asian market, gold colored paper, brown kraft paper, and tissue paper in black and purple.

7 **Create a Glue Mixture and Tear Collage Papers**
Mix white craft glue (such as Elmer's School Glue) with water (2 parts glue to 1 part water) and keep in a plastic container with a lid. Elmer's School Glue is forgiving because it can be washed off your work, and you can remove collage paper that is not working by soaking it with a wet paper towel, even when dried.

Prepare for the next step by tearing some small bits of black tissue paper.

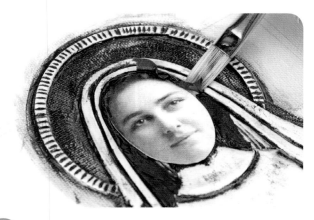

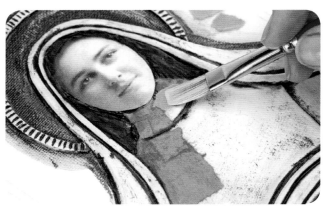

8 **Paper the Hair**
Using a medium brush, apply some of the glue mixture to the hair area. Apply the small strips of black tissue paper to the surface, painting over them with the glue mixture until the area is covered. Push the tissue into place with your brush; crinkles and folds add to the texture. Carefully wipe the face clean with a damp paper towel to clean off the glue mixture.

9 **Paper the Neck and Bodice**
Tear small bits of brown kraft paper for the neck and bodice. Always tear small bits of paper to prepare for papering so you can move forward with ease.

Whenever gluing paper down, brush your glue mixture on the surface of your art and then paint over each piece of paper you add. Remove all excess glue with your brush.

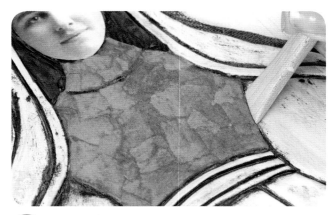

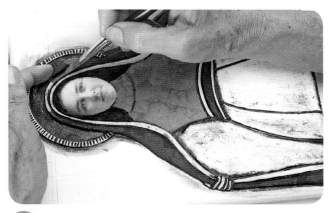

10 **Tuck the Paper**
Use a clay tool to tuck the paper edges into the crevices of the neck and bodice.

11 **Paper the Veil and Belt**
To have continuity in collage work, it is good to use the same paper in more than one location. In the example, I chose purple tissue paper for the veil and belt. Be sure to tuck the edges into the crevices with your clay tool.

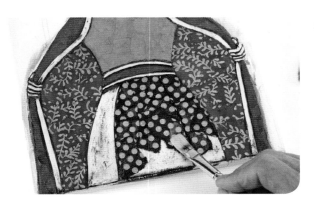

12 **Continue Papering the Entire Figure**
Add decorative papers to the skirt and inside of the veil. Leave the trim white for now as it will be painted. Be sure to tuck the paper into the crevices of the skirt and veil.

It works well to carefully paper around the edges of shapes first, cutting or tearing some as needed for fitting, and then fill in the middle.

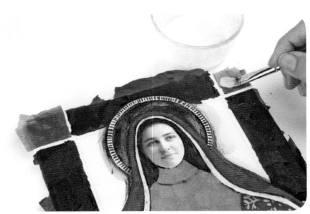

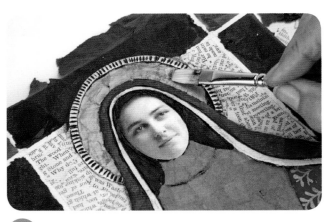

13 **Paper the Border**
Using the guideline from your tracing, collage up to the edges with various papers such as black tissue paper for the edges and red paper for the corners.

14 **Paper the Halo and Background**
Paper inside the halo with metallic gold paper and use book pages for the inner background.

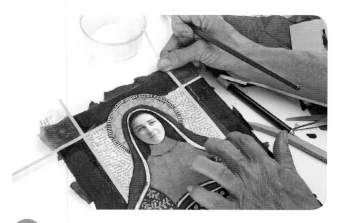

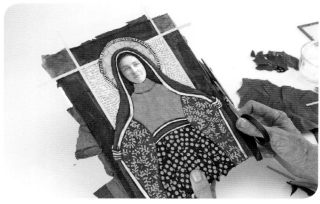

15 Add Paper Strips

Cut thin strips of gold paper to add over the collaged papers to form the straight edges of the background. Use a craft knife to cut along edges of the halo and where the strips run into the figure.

16 Trim the Edges

When you are finished papering the entire piece, allow it to dry completely. At this stage your substrate's edges will be quite rough. Trim them with scissors and lightly sand the substrate edges to a smooth finish.

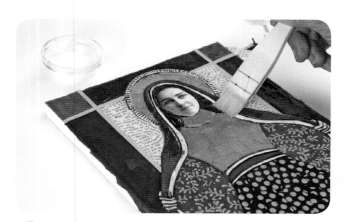

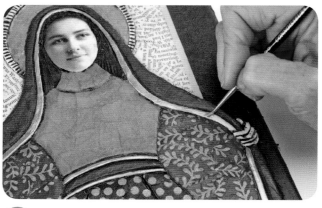

17 Paint the Collaged Papers with Medium

Paint over the entire piece with two thin coats of matte medium. This will protect and seal the paper. Be sure not to let the medium pool in any corners.

18 Paint the Trim

Paint the trim of the veil and belt using metallic gold paint and a detail brush. Paint carefully and wipe away any accidents with a damp paper towel while the paint is still wet. The protective coat of medium helps prevent the paint from staining the papers.

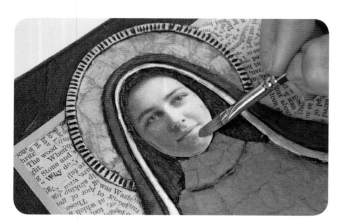

19 Paint the Face and Hands

Mix a tiny bit of Azo Yellow and Quinacridone Rose to make a transparent colored wash. Use a detail brush and paint the hands. Use a medium-size wet brush and very little paint and wash over the face, taking care to avoid the eyes. If it looks too dark, blot the paint until it looks right. You can always wash it off and try it again before it dries.

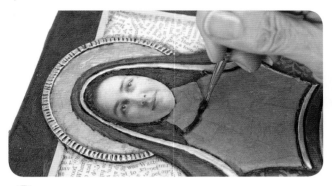

20 Enhance the Details

Enhance the edges of the figure with black on all sides and a detail brush to get a vintage look and tie the piece together. Paint around the edge of the halo with metallic gold paint, and accentuate her lips and cheeks with a soft Quinacridone Rose wash.

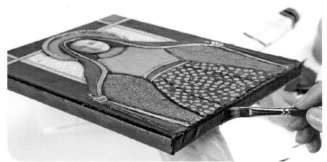

21 Paint the Edges of the Substrate

Paint the substrate's edges black for a finished look. It may take two coats.

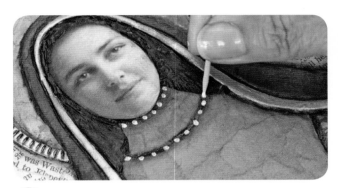

22 Detail the Necklace

Use a toothpick and Titanium White to add small dots around the neck areas.

23 Detail the Border

If desired, add more details to the border. Here I added a stellar pattern to the black border with Titanium White and a toothpick.

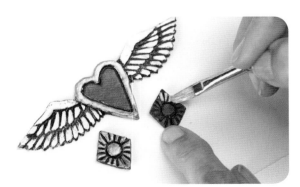

24 Paint the Heart and Corner Diamonds

The winged heart is the foremost focal point and deserves careful painting and touch-up. Using Azo Yellow and Quinacridone Rose, mix a red color for the inside of the heart that goes with your color scheme and enhance it with a wash of black. Touch up the white areas with a bit of Titanium White. Paint the corner diamonds and the trim around the heart with metallic gold paint.

25 Glue Down the Embellishments

Finish up your lovely lady by gluing down the wings and corner embellishments with white craft glue. Be sure to cover their backs with glue completely. Press down well on all edges and remove any glue that peeks out from the edges with a clean detail brush. Once the glue has dried, paint the winged heart and the corner diamonds with two coats of matte or gloss medium, depending upon the look you want.

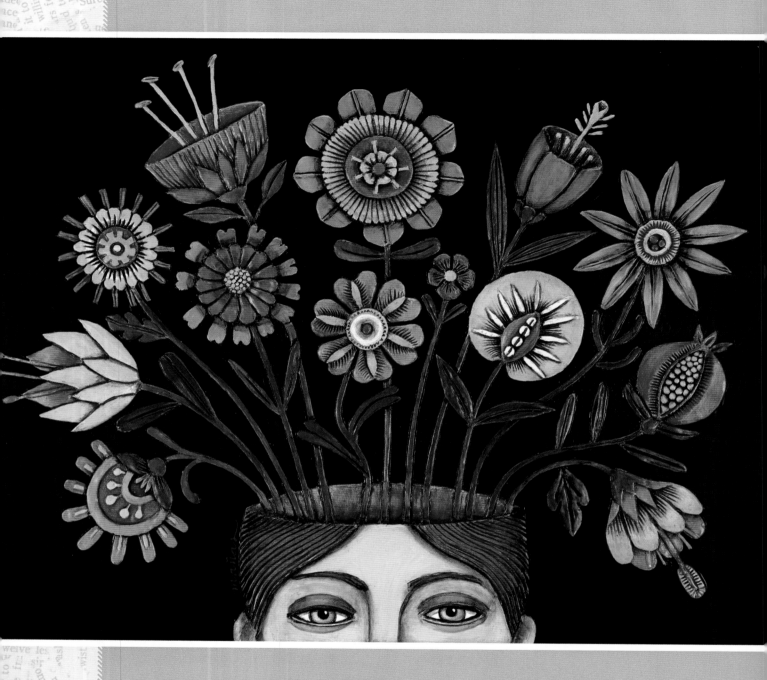

JUST IMAGINE
Paper clay and acrylic on
wood panel
14" × 18" (36cm × 46cm)

CREATIVE *projects* 4

Now that you have learned the tricks and techniques of working with paper clay and finishing it, it's time to unleash your imagination and do your thing. In this section, you will find a variety of projects and ideas to help spark your creativity. Learn more fun and forgiving mixed-media techniques as well as new ways to use paper clay in two- and three-dimensional pieces. Plus find some great inexpensive framing ideas to showcase your work.

Practice Makes Almost Perfect

What you do not see in this book are my experiments and failures. In the ten years I have been working with paper clay, I have plenty of both. I have come to respect and love the process no matter how something turns out.

The true joy of making art comes from doing it, not staring at your finished piece. However, if it turns out well, you are inspired to make more. On the other hand, if it is an epic failure, you will work hard trying to fix it. So either way, much can be learned, but I think you grow more when you fail.

Play with the Clay

Simple, easy projects can be a fun way to practice and develop your skills. Start with a simple design and sculpt four different versions of it. You can vary your clay working techniques for each.

Below are four versions of a bowl and chopsticks that I created on 5" × 5" (13cm × 13cm) panels, a good size for practicing sculpting and finishing techniques. On the following pages you'll find some of my favorite fixes and finishes for when something just doesn't work, such as how to add detail to dried clay, and mixed-media techniques for altering backgrounds. Use the pattern below to practice and develop your own style while also sharpening your skills.

Practice Patterns
Here is the rice bowl pattern to help you get started. As with all the patterns in this book, you do not need to follow exactly. Even I do not follow my own patterns to the T. You will bring your own creative style to whatever you make.

Version 1

I cut the simple bowl shape, placed it on the board and then sculpted it with very loose, sketch-like strokes. I added the chopsticks with two strips of clay afterwards. This loose style is very quick and imperfect.

Version 2

This version is more of a drawn style, rather than being loose like a sketch. And once again, the chopsticks, added afterwards, create the mood.

Version 3

Very simple, plain clay work allows for more finishing options. This version is very flat with no shading strokes. When it was dry, I sanded the surface to make it extra smooth.

Version 4

By simply changing the chopstick placement, you can change the composition. This piece was also sanded.

Practice Pattern Printouts

Visit **artfulpaperclay.com** to download these and other patterns in this book to print out for your own projects!

Black and Not So White

Pages from old books make great collage material. They can add textural interest to a background yet act as a neutral. Plus they can be toned with transparent washes to any color. I make a mixture of Elmer's School Glue and water (60:40) to use as the glue for collage work. Then when the work is finished and dried, I paint it with acrylic medium to seal it.

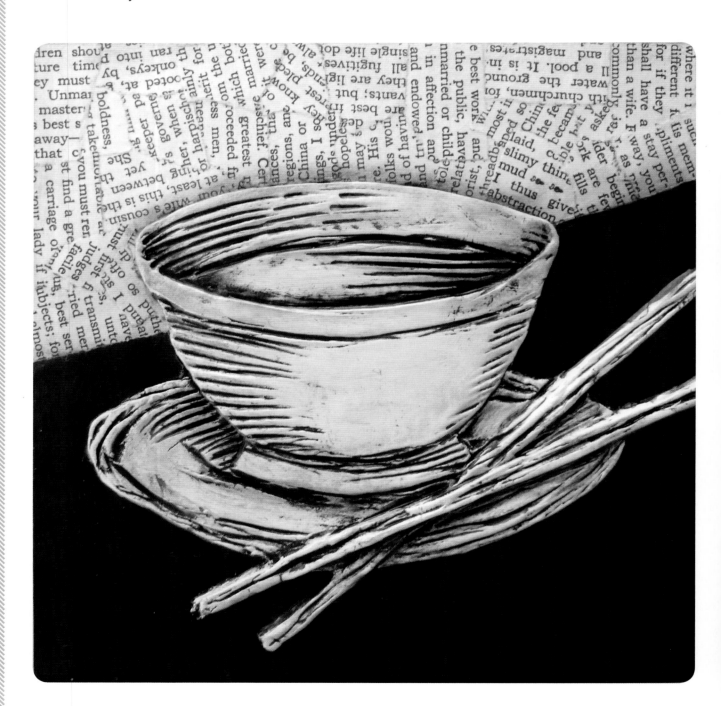

1 This piece was sealed with gesso and medium, then black paint was applied and removed with alcohol. I like the look of black and white, and often leave my work like this.

2 Before adding the torn book paper background, I painted the tabletop black. That way I don't get paint on the paper.

3 I used a metal ruler to tear columns from book pages so that each strip was solid type without gutters or margins. Next I tore each strip into pieces. I painted my glue mixture on the board, applied each piece of paper and painted over it, overlapping as needed. I paper around objects first and then fill in the middle.

4 When the collage work was dry, I sealed everything with acrylic medium. I added a light wash of Transparent Yellow Iron Oxide over everything to give the clay and background a similar tone. I also painted a light wash of black where shadows might fall. I trimmed excess paper from the edges with a craft knife and sandpaper.

5 At this stage I could have tinted it any color, like blue or sepia, by mixing a color wash using a transparent paint.

Transparent Color Harmony

Because transparent colors are see-through, you can layer them over each other to achieve a softer look. Whatever color is underneath will affect the colors applied on top of it. This is when analogous colors work best. They sit next to each other on the color wheel and tend to mix well and look good together because they are closely related. For this example I also added a simple textured background with colored tissue paper, which acts as a wonderful underpainting.

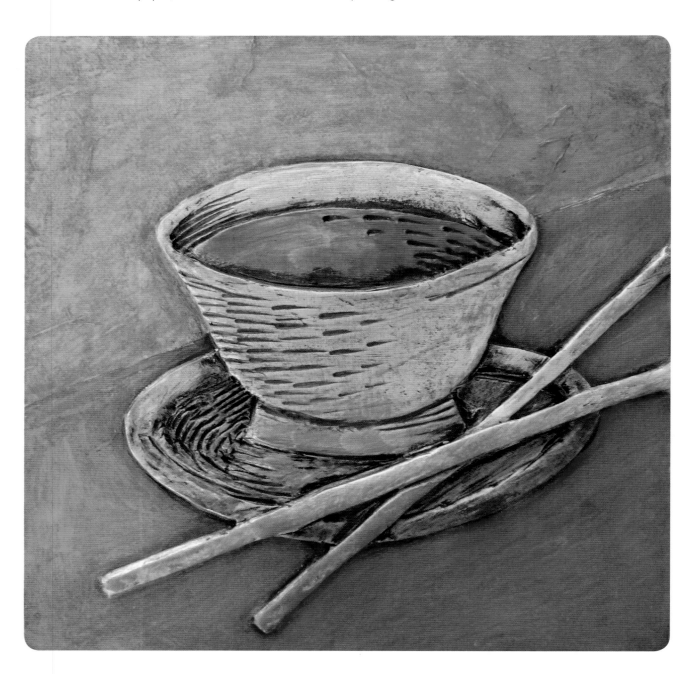

1 This simple bowl was coated with gesso and acrylic medium, painted black, and then the paint was removed with alcohol. White is the best background for transparent paints.

 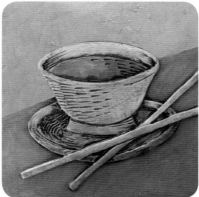

2 I began by staining the entire image with a wash of Transparent Yellow Iron Oxide. Since I plan to paint this with transparent paints, the underpainting will tint all the colors, creating color harmony. I allowed the paint to dry and cure.

3 I painted the saucer with a wash of Phthalocyanine Blue, the table top with a wash of Quinacridone Rose mixed with Azo Yellow and a tiny bit of white. Inside the bowl was painted with more of the Transparent Yellow Iron Oxide, dabbing some rose in the right corner of the bowl.

4 When the underpainting had dried with nice tinted colors, I tore bits of yellow-orange tissue and used my glue mixture to paper the background. The more wrinkles and folds, the better. When it had all dried, I sealed it with acrylic medium before painting over it so the glue would not interfere with any paint coverage.

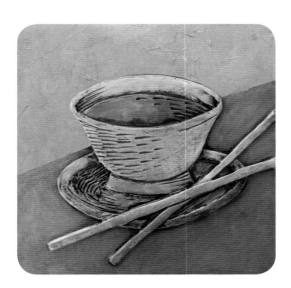

5 To help integrate the background with the foreground, I painted a thin wash of Phthalocyanine Blue (the saucer color) over the background. When it was dry, I removed some of the paint with alcohol and a paper towel, which left a hint of blue and let the background papering show through. Pure harmony!

Plain and Simple

There are times when I finish my clay work and after it dries, I realize I should have done more. Dried clay can be easily carved and embossed to add detail. Embossing with a ball stylus embossing tool is like shallow engraving, good for adding delicate details like the veins of a leaf. For the best results, it is important to carve or emboss dried clay before applying gesso or medium to the clay.

Once again, tissue paper makes a good textured background. But this time, the paint over top is opaque. I used a scumbling painting technique where the top layer of color is brushed over another in broken strokes so that patches of the color beneath show through. The paint catches on the tops of the folds and wrinkles for added texture.

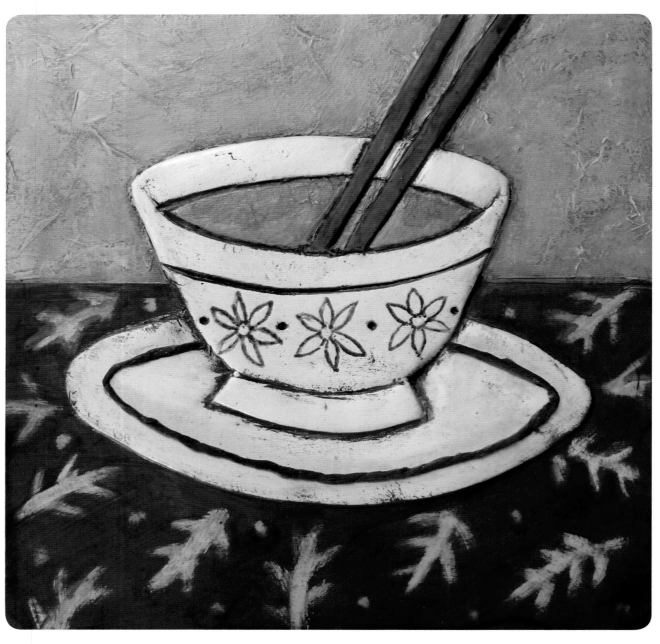

 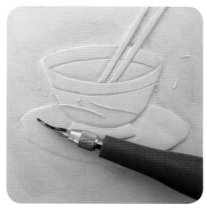 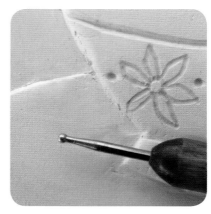

1 This simple clay work design had dried but felt a bit too plain. Before I coated it with gesso and medium, I used a Speedball Linoleum Cutter with a no. 1 blade (small V shape) to carve a stripe into the bowl. Carving works best for simple lines without much curve. Then I used a ball stylus tool to emboss flowers in the bowl by pressing firmly.

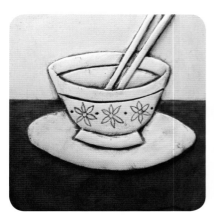

2 I coated the clay works with gesso and medium as usual, and then painted the entire piece a deep blue color. I then removed the paint from the bowl and background with alcohol, leaving the tabletop solid blue.

3 After touching up the paint, I used alcohol to create a leaf pattern in the tabletop by painting with alcohol using a small, stiff brush. While it was still wet, I blotted away the excess paint with a paper towel. The result is a wiped paint effect that looks compatible with the wiped paint on the clay. I use this method to add details to backgrounds that seem too solid.

The saucer was asking for more detail. And I had already painted the clay surface, so I could not carve or emboss it. So using a thin strip of blue tissue paper, I wet my fingers with the glue mixture and twisted the tissue paper into a cord. Then I glued it into place on the saucer. This is a good fix for when you get to the end of a piece and realize it needs something more.

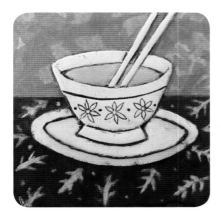

4 After applying pink tissue to the background and yellow tissue to the inside of the cup, I sealed everything with acrylic matte medium. I painted opaque yellow over the pink tissue and opaque pink over the yellow without adding water to my paint. In the finished piece, the chopsticks ended up a dark blue!

Opaque Color Pop

When painting over a dark color like black, opaque paints will work best. It will usually take more than one coat to cover the black completely. For more of a folk-art look, you can let hints of the color beneath show through by dabbing the paint over the surface. The black will accent the colors on top, making them appear more intense and brilliant.

Adding lettering to paper clay is best done when the clay is dry, using metal stamping letters. Trying to imprint words into wet clay can have mixed results. The letters may not appear as crisp as they should, or the clay will push up around the edges of each letter, creating an uneven look.

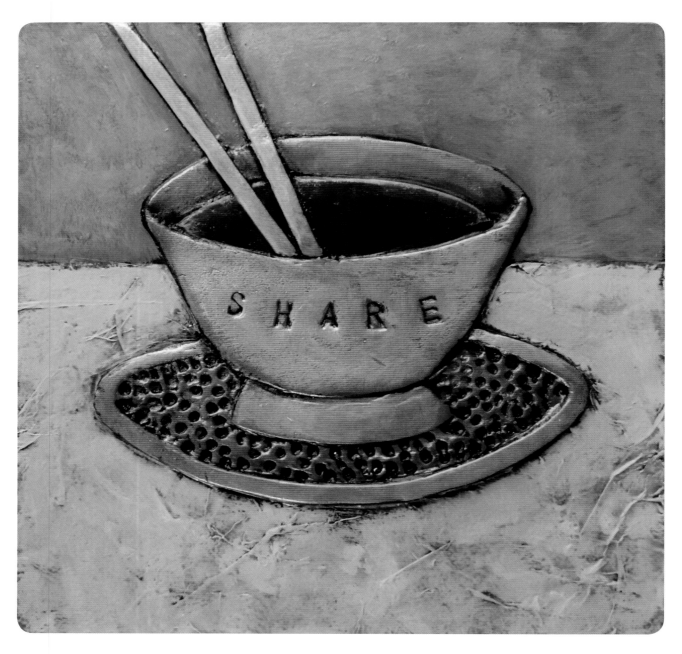

1 I began with a very simple clay work design and let it dry completely. Simple designs work best adding texture and interest with color.

2 Before I painted my clay work with gesso, I used metal stamping letters and pressed a word into the dried clay. It works best to rock the letters back and forth while applying even pressure.

3 After sealing everything with gesso, I painted the entire piece with two coats of black. Then I applied opaque paint to the surface over the black, taking care not to use any water in the paint and adding a bit of white to my colors to help them stand out. I used a dabbing kind of stroke, which you can see in the green background where some of the black shows through.

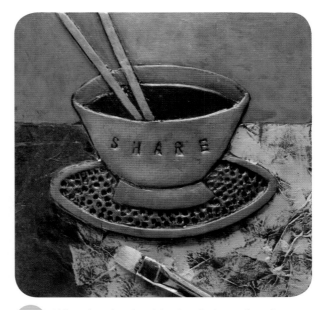

4 I added texture to the tabletop by applying dark green tissue paper using the same method as on the previous pages. The more folds and wrinkles, the better. Notice how the black color affects the transparent tissue by making a dark green even darker.

5 When the glue dried, I painted a layer of acrylic matte medium over the paper to seal it. Then I mixed an opaque blue color and lightly brushed it over the surface of the paper without adding any water to the paint. The colored tissue works as an underpainting. The paint catches on the tops of the wrinkles and folds, creating a wonderful textured finish. Finally I scumbled lighter versions of all the colors over them to brighten everything up, using very dry paint. I added a blue highlight to the black area inside the cup.

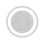

Paper Clay Idea Gallery

There are so many uses for paper clay, it would take another book to show them all. Remember, it is usually used in doll and figurine making, and there are hundreds of examples of them online. Here are just a few more ideas for using the clay in bas-relief using the same techniques you learned in this book.

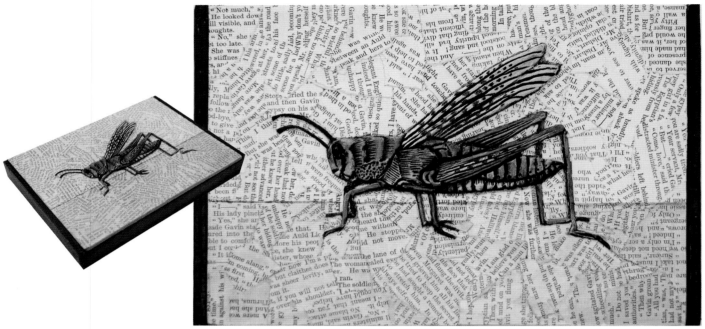

Paper Clay Box Top
Wooden boxes make terrific substrates and great gifts. With a little sanding and a coat of gesso on the lid, it is ready for clay work. Be sure to apply a few coats of acrylic medium over everything to seal it. This example was made from a cigar box and was a Christmas gift for my grandson Peter, the grasshopper catcher. I put some money inside when I gave it to him. The money is long gone, but he still has the box.

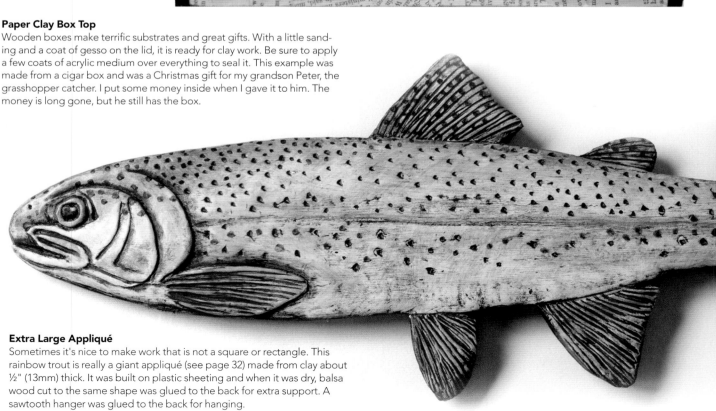

Extra Large Appliqué
Sometimes it's nice to make work that is not a square or rectangle. This rainbow trout is really a giant appliqué (see page 32) made from clay about ½" (13mm) thick. It was built on plastic sheeting and when it was dry, balsa wood cut to the same shape was glued to the back for extra support. A sawtooth hanger was glued to the back for hanging.

Lampshade Detail

Paper Clay Lampshade

Bring new life to an old lampshade. A light-colored shade, made from a tightly woven fabric rather than linen or burlap, works best. I painted the plain shade with a thin, even coat of gesso before applying the clay. For this design I cut narrow strips of clay and pressed them to the shade to make all the stems before adding any leaves. Then I added the leaves, one by one, sculpting as I went along. When it dried, I painted everything with another thin coat of gesso and a final coat of matte medium. In the daylight, the paper clay has a sculptural look; at night, it is backlit when the shade gets illuminated.

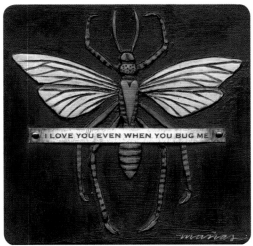

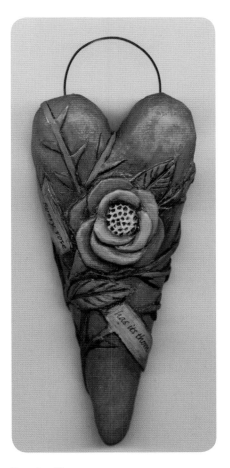

Add a Valentine Message

Make paper clay with a message. I glued a laser print to a piece of mat board, coated it with acrylic medium and antiqued it to make the message for this piece. I glued it in place with wood glue and used little brass nails to push into the ends for a more finished look.

Hanging Heart

This heart has a Styrofoam core that I encased with paper clay. When it dried, I added more clay to the top to sculpt the rose, banner, stems and leaves. A long piece of wire pushed into the top formed the hanger. Spoiler alert: The clay does not want to stick to Styrofoam, so be sure to paint your form with gesso first.

 # Framing Ideas

Even though I paint the edges of my boards and canvases to avoid framing them, there is no question that framing brings prominence and stature to your clay works. If your piece has clay to the edge of the board or canvas, it will have an uneven surface and may not work in a regular frame. Here are some alternative framing solutions.

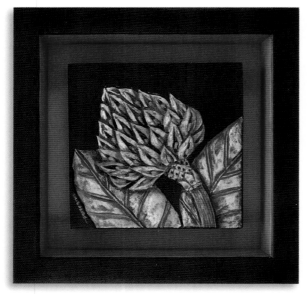

Cradled Panel Frame 1
The same cradled panels used as substrates can be flipped over and used as frames for smaller pieces. Sand them with fine-grain sandpaper before painting them with acrylic paints and varnish them with acrylic medium. Use wood glue to hold your work inside.

Cradled Panel Frame 2
If your work is on a thin board, consider gluing in a wood block or some mat board under your art to elevate it slightly so it appears to float in the frame. Very cool effect.

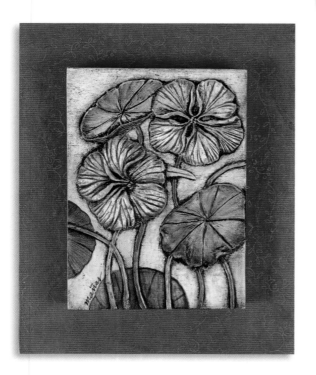

Platform Panel Frame
Another great option is to cover a larger cradled panel with paper or paint, and mount a smaller cradled panel on top of it. Join the two with tiny wood screws from the backside for larger pieces or use wood glue for smaller ones.

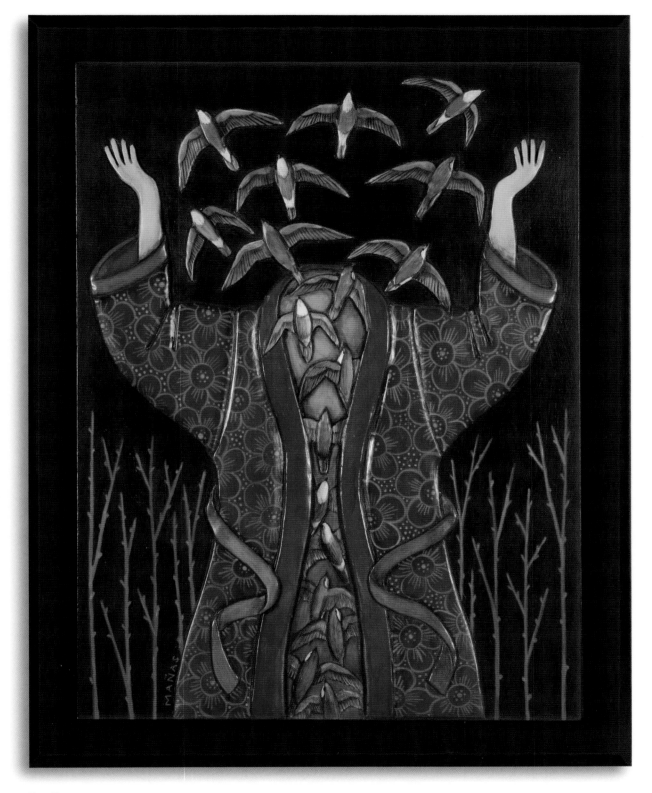

Box Frame

Box frames work great because the image is recessed into a box. I have these simple frames made by a high school shop class. I then paint them to match my artwork, which I elevate slightly using thin pieces of wood held in place with wood glue. You can also use cigar boxes for smaller pieces.

Resources

Brushes (Connoisseur)
connoisseurart.com

Canvases, Artist Panels and Wipe Out Tools (Art Advantage)
art-advantage.com

Paints and Mediums (M. Graham & Co.)
mgraham.com

Air Dry Clay (Creative Paperclay)
paperclay.com

Gesso and Primer Brushes (Pro Art)
proart.com

Tracing Paper for Patterns (Alvin)
alvinco.com

Craft Knives and Blades (X-Acto)
x-acto.com

Sculpting, Modeling and Embossing Tools (Kemper)
kempertools.com

Mini Board Packages (Lara's Craft)
3" × 2" (8cm × 5cm) unfinished wooden rectangle signs with rounded corners (sold in sets of 6 pieces)
larascraft.com/hallway.html

Wooden Tags (Recollections)
3½" × 1⅝" (9cm × 4cm) Wood Embellishments by Recollections (sold in sets of 10 pieces)
michaels.com

AIR-HARDENING CLAY ALTERNATIVES

The following air-hardening clays can be used as alternatives for Creative Paperclay, which is what I am most familiar with using. After testing them, I found that with practice, they could all work well for this process.

1) La Doll Stone Clay (Padico)

This clay has a nice fine grain and is fibrous. It seems most like Creative Paperclay in that the fibers allow it to have a bit of flex when it dries. It comes in 1.1 lb. (500g) packages only.
padicoshop.net

2) La Doll Premier Light Weight Stone Clay (Padico)

This is very similar to clay no. 1, is about half the weight, is even finer grained, has no fibers and very little flex. It is bright white and has a slight marshmallow feel. The manufacturer said it might yellow over time. It comes in 10.58 oz. (300g) packages only.
padicoshop.net

3) La Doll Premix (Padico)

This clay is a mixture of clays no. 1 and no. 2, giving it a more durable feel when dried. It is also bright white like clay no. 2, does not have much flex and also might yellow over time. It comes in 14.11 oz. (400g) packages only.
padicoshop.net

4) Fimo Air Basic (Staedtler)

This clay is stickier than the others but with a little finessing, it works just fine. It seems more like an earthen clay with less fibers and less flex when dried.
staedtler.com

5) Polyform Model Air (Polyform Products Company)

This clay has a nice texture and works well. It's fibrous and has good flex when dry. It comes in 1.1 lb. (500g) packages only.
sculpey.com

Share Your Artwork Online!

Visit **artfulpaperclay.com** to share your completed paper clay projects and artwork with Rogene and her fans. Or get inspired by checking out what others are doing with this new art form.

THE GIFT OF VOICE
Paper clay and acrylic
on canvas
14" × 11" (36cm × 28cm)

Index

About the Author

Since 1975 Rogene has worked as a graphic designer, art director and creative director for advertising, public relations and design firms in Eugene, Oregon, and for more than 30 years she has been a partner in a successful international card company called PhotoTidings. In 2006 Rogene retired from her company and became a full-time artist. She studied painting, drawing, sculpture and jewelry making at the University of Oregon and through the years has taught art in a variety of settings, including artist-in-residence programs, schools and art centers, as well as giving private lessons in her own studio. Presently, Rogene teaches mixed-media workshops in Oregon, Washington and California, and is planning some special workshop tours to Mexico. Visit her website at rogenemanas.com.

Dedication

To my mother, Bruna Marie Manas, who died from Alzheimer's disease in the summer of 2004. In the week that followed her death, I created a portrait of her as a child, my first paper clay bas-relief. It was born from an idea I'd never had time to pursue. Thank you, mom, for being inventive, creative, frugal and resourceful. And for teaching me what your mother taught you: "Never say can't."

To my husband, Rick, who is the most supportive, encouraging, loving, kind, honest, helpful and entertaining husband an artist could want.

To my son, Geno, and my daughter, Aja, who inspired me to work hard to become my best self. And who are truly my greatest works of art.

And to everyone who has liked my work, purchased my art, taken my workshops or given me an encouraging word. Thank you all so very much.

Acknowledgments

A big thank you to Dan Justus of C2F, wholesaler of fine art, craft, graphic art and drafting supplies, that provided most of the materials photographed for this book. And thank you to M. Graham & Co. for supplying all the paints and mediums photographed for this book.

Other fine North Light Books are available from your favorite bookstore, art supply store or online supplier. Visit our website at fwcommunity.com.

a content + ecommerce company

20 19 18 17 16 5 4 3 2 1

DISTRIBUTED IN CANADA BY FRASER DIRECT
100 Armstrong Avenue
Georgetown, ON, Canada L7G 5S4
Tel: (905) 877-4411

DISTRIBUTED IN THE U.K. AND EUROPE
BY F&W MEDIA INTERNATIONAL LTD
Brunel House, Forde Close, Newton Abbot, TQ12 4PU, UK
Tel: (+44) 1626 323200, Fax: (+44) 1626 323319
Email: enquiries@fwmedia.com

ISBN 13: 978-1-4403-4130-4

Edited by Sarah Laichas
Interior design by Laura Kagemann
Cover by Breanna Loebach
Production coordinated by Jennifer Bass

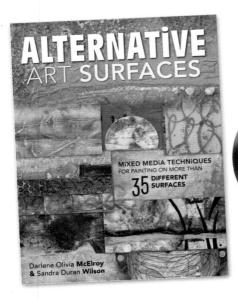